DISCARD

The Getty Conservation Institute

Picture **LA** Landmarks of a new generation

Cover photo:
Abbey Fuchs
Los Angeles River tunnel

Half title photo:
Jessica Karman
Ennis Beley

Back cover photo:
Jessica Karman
The photographers

Library of Congress Cataloging-in-Publication Data

Picture LA : landmarks of a new generation.
 p. cm.
 Edited by Jeffrey Levin.
 ISBN 0-89236-305-3 : $19.95
 1. Los Angeles (Calif.) — Pictorial works — Exhibitions.
2. Architecture — California — Los Angeles — Pictorial works —
Exhibitions. 3. Los Angeles (Calif.) — Buildings, structures, etc. —
Pictorial works — Exhibitions. I. Getty Conservation Institute.
II. Levin, Jeffrey.
F869.L843P53 1994
979.4′ 94 — dc20 94-31176
 CIP

This book is published in conjunction with "Picture L.A.: Landmarks of a New Generation,"
an exhibition organized by the Getty Conservation Institute which opened at the Henry P. Rio Bridge Gallery
at Los Angeles City Hall in December, 1994.

The Getty Conservation Institute (GCI),

an operating program of the J. Paul Getty

Trust, is committed to raising public

awareness of the importance of preserving

cultural heritage worldwide and to further-

ing scientific knowledge and professional

practice in the field of conservation.

The Institute conducts research, training,

documentation, and conservation activities

in several major areas including objects

and collections, archaeological sites

and monuments, and historic buildings

and cities.

Contents

Landmarks 1
Miguel Angel Corzo

Picturing LA 4
Lauren Greenfield

The Photographs 7

Afterword 97
Warren Olney

The Photographers 99

Biographies 107

Project Participants 112

Acknowledgments 114

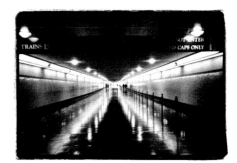

Luis Castro
Union Station, *downtown Los Angeles*

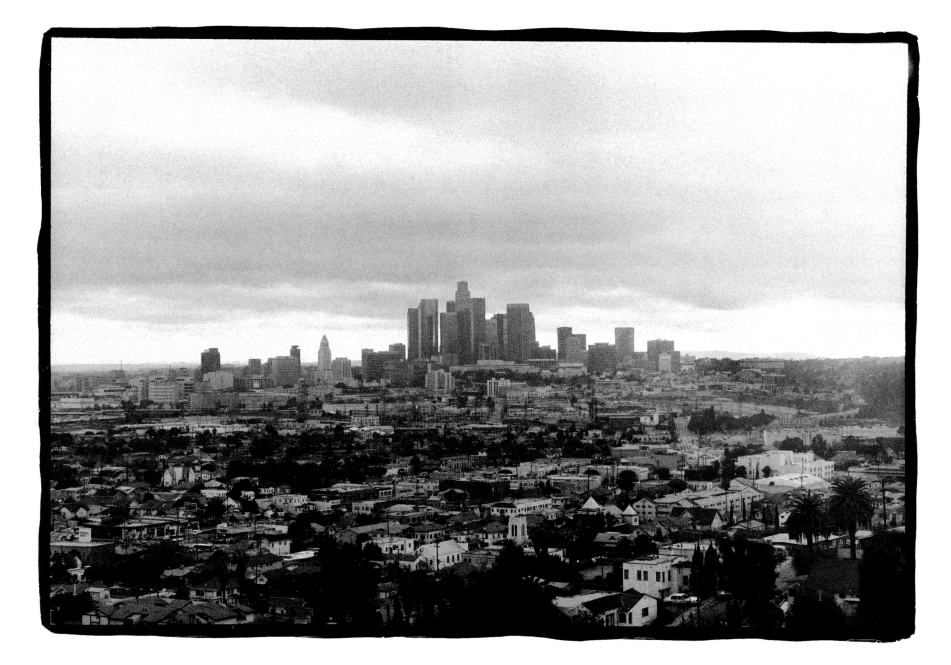

Daniel Hernandez
Downtown skyline from Daniel's backyard, *Boyle Heights*

Landmarks

What is a landmark?

At first glance, this appears a relatively simple question. For those of us engaged professionally in the preservation of cultural heritage, the answer would seem obvious—a place of cultural or historical importance.

However, this answer raises almost immediately other questions. How old is something before it becomes "historical"? And whose culture are we talking about?

Several years ago, the J. Paul Getty Trust began asking these questions about the community that is its home.

Los Angeles is among the youngest of the world's major cities, a place where the urban landscape is continually undergoing change. This constant physical alteration is matched by the ever-changing demographic profile of Los Angeles, a city populated by people whose families have been here for generations or perhaps only since last week.

In a city so marked by ceaseless transformation, is it possible to define its landmarks in absolute or conventional terms?

In 1992 we at the Getty Conservation Institute conducted a study of Los Angeles landmarks, their relationship to the city's history, and their use. While the study provided extensive information on officially designated landmarks, it fell short of answering the questions raised by the city's sprawling spatial and human landscape. It showed us the Eiffel Towers, the Taj Mahals, and the Golden Gates of Los Angeles. But in a city that is steadily reinventing itself, where people come together more often on freeways than on central squares, it did not tell us how official landmarks connected to people's lives. Were we perhaps ignoring categories of landmarks that fell outside the kinds of definitions embraced by older societies? If so, what were they?

We decided to gather together a group of ethnically diverse youths to get a fresh perspective on what constitutes a landmark. Specifically, we thought that asking young people to photograph sites they considered to be landmarks would give us an insight into values less well known or appreciated.

After seeing an exhibition of her work on Los Angeles youth, I invited Lauren Greenfield, an outstanding young photographer, to supervise the photographic aspect of the project. Through school programs and community centers, she selected young people from various parts of the city. During a three-month period, the project participants went into their own communities and around the

city photographing personally significant social and architectural landmarks, as well as designated heritage sites.

The photographs collected here are the stunning result.

The first thing that struck me upon seeing these images was their incredible diversity. The photographers clearly had few preconceived ideas about landmarks. As defined by these photographs, landmarks can be a geographical reference, a monument, a mobile object, or a state of mind. Even a fleeting moment — the kind that recurs again and again — can become a landmark in someone's mind. Cars cruising on Crenshaw Boulevard is a moment in time, but when the cruising happens every Sunday night, it's a landmark.

A second thing I saw in these photographs was a humanization and a personalization of landmarks. Typically, landmarks are photographed dramatically lit and without people. The landmarks here were shot under natural light and many serve as a backdrop to human activity. The pictures, for example, of the syncopated roller skaters on the Venice boardwalk or the young women taking photographs on Hollywood Boulevard are meaningful to a great extent because of their living, dynamic quality, not because

of the surrounding architectural forms.

The third thing I found in this body of work was an extraordinary desire by these young people to communicate their vision. This was not another school project. This was something into which they put a remarkable amount of thinking and feeling. Their photographs speak to us about important parts of their world, be it a Korean temple or the local barber shop.

Depicted here are landmarks of Los Angeles life. The amusement rides on the Santa Monica Pier evoke the beach and a sense of fun, but they also recall the past — they stand on the last of the amusement piers that once lined Santa Monica Bay. The burnt wreckage of a car in the smoldering aftermath of the Malibu fire reminds us that while L.A. may be the city of the automobile, it is also a place where nature is a particularly powerful presence in the city's life. The stark, post-earthquake image of the Santa Monica Freeway snapped like a popsicle stick is proof enough of that. If there is a subtextual message in these latter two images for those of us in conservation it is that cultural and natural preservation are increasingly linked.

For me personally, the photographs were evocative in another way. I was raised in Mexico City where

thousand-year-old historical landmarks were a real and present part of my growing up. Yet there were other landmarks, too, ones that gave me a sense of comfort, belonging, and identity — a park near my house, a stop where the bus picked me up for school, and the street where I lived. As I looked at the "Picture L.A." photographs and reflected upon them, these memories returned to me. I was taken back to what my landmarks were when I was a child, and realized that even today seeing these places gives me a sense of rootedness and continuity.

Why is protecting a landmark important? Because places *matter*. In a world where the only real constant is change, what do we have to cling to in the vortex of change? Landmarks — the places that act as our geographical touchstones, that give us a sense of community, and that bind us together in awe, pride, and pleasure. While many of the landmarks of our childhood may disappear, much that characterizes who we are and where we live can and must be preserved for the sake of our identity. Indeed, working together to care for the places that matter unifies us and binds us in ways few other communal actions can.

To me that is the educational function of this project. We have pointed these

young photographers in the direction of thinking about the value of maintaining something important to their identity. This experience has changed them, and as they mature they will, I believe, recognize more fully the importance of preserving those communal landmarks that connect us to each other and hold our city together.

At the same time, with their photographs and their words, they have educated us, not only about a youthful vision of landmarks, but also about the young's capacity to become powerful voices. I hope these photographs provoke a sense of wonderment and stimulate people into reflecting on their own values and attachments. As much as anything, I hope that "Picture L.A." prompts a new respect for the young. For critics of young people's values today, I say look at these images created by eight young people from around the city, and see what they are capable of at this time in their lives.

I want to see them twenty years down the line.

"Picture L.A.: Landmarks of a New Generation" involved the efforts of many. There are the photographers themselves — Ennis Beley, Luis Castro, Abbey Fuchs, Daniel Hernandez, Raul Herrera, Sabrina Paschal, Younghee Seo, and Osofu Washington — each of whom provided us with a unique vision of the city that is their home.

Bringing her own creative vision to the project was Lauren Greenfield who selected the participants and skillfully guided them in turning their attitudes and feelings into evocative photographic expression. With energy, imagination, and professionalism she helped accomplish the project's goals and present its results.

Al Nodal and Earl Sherburn of the Los Angeles Department of Cultural Affairs offered early and continued support to the project. Claire Bartels of the Department of General Services facilitated the preparation of the Henry P. Rio Bridge Gallery at Los Angeles City Hall where the exhibition of the photographs was first held.

As coordinator of the project, Anita Keys diligently attended to the numerous details that "Picture L.A." entailed. Jeffrey Levin, editor of this catalogue, helped create a unifying form and structure for the pictures and words of the photographers.

Finally, I wish to thank Mahasti Afshar of the Getty Conservation Institute who designed the project and supervised the complicated process of turning a simply stated concept into "Picture L.A." Her initial enthusiasm for the idea, her imagination, and her earnest dedication to the project are in great measure responsible for bringing together the astonishing and haunting set of images collected here.

Miguel Angel Corzo
Director
The Getty Conservation Institute

When the Getty Conservation Institute decided to ask young people to identify the landmarks of their communities, it recognized photography as the perfect medium for cultural exploration and discovery. Whether on one's own street or far from home, a camera can provide the motivation and the mask with which to bypass usual inhibitions to explore the unexplored and rediscover the ordinary.

Although I was raised in Los Angeles and lived on the west side until I went away to college, most of the urban and suburban sprawl that makes up L.A. was virtually unknown to me when I returned here as a photographer in 1991. Just as I discovered Los Angeles through my own work, I hoped that young people would discover landmarks through "Picture L.A." The project was an opportunity for a diverse group of kids to document the people and places with which they were intimately connected, and thus introduce each other and the public to an inside view of their communities. As Osofu Washington said eloquently in one of his interviews, "if people can understand our landmarks, they can see things from our point of view."

In creating a framework for the photography, I was guided by the dictionary definition of a landmark as:

- *a prominent or identifying feature of the landscape;*
- *a conspicuous object that marks a course or serves as a guide;*
- *an object that can be used to define a locality;*
- *an object that marks the boundary of land;*
- *an event that marks a turning point.*

My first challenge was to find creative young people willing to engage in original thinking about the notion of landmarks. In interviewing kids from a variety of schools and community organizations, I was looking for vision and ideas as well as photographic experience. I found these qualities in Ennis Beley, Luis Castro, Abbey Fuchs, Daniel Hernandez, Raul Herrera, Sabrina Paschal, Younghee Seo, and Osofu Washington. They ranged in age from ten to eighteen and hailed from such diverse L.A. communities as South Central Los Angeles, Koreatown, Hollywood, Boyle Heights, Watts, and Inglewood.

My aim was for the young people to follow their hearts in terms of subject matter and style, and not be overly distracted by the technical side of photography. Accordingly, I chose point-and-shoot auto-exposure cameras with zoom lenses and optional flash capability. We used for-giving black-and-white film which enabled the kids to make pictures in diverse lighting conditions. I taught the participants minimal techniques: how to modify shutter speed, controlling use of the flash, when to use faster-speed film, and when to use a tripod. The kids learned much through experimentation. I asked them to photograph as often as possible and to keep journals recording their experiences. I looked at their contact sheets every week and spoke to them over the phone about what worked in their pictures, what they were trying to convey, what places or ideas merited revisiting, and what they wanted to shoot next.

For over twelve weeks, the photographers worked independently in the field with the help of Jessica Karman, Juliann Tallino, and myself (as well as family and friends). We facilitated their creative impulses with transportation, moral, and logistical support. In the field, we understood that our role was to accompany and encourage the photographers without interfering with their vision or intuition. They looked at their surroundings with unflinching and inclusive eyes. For them, a landmark included not only the built environment, but also the people living there, a car speeding by, a passerby, a homeless person on the street corner, a court case affecting their community, or a neighborhood transformed by natural disaster.

While some of the pictures are timeless, "Picture L.A." documents a specific period in Los Angeles history. Ennis, a thirteen year old from South Central L.A., photographed many of the landmarks relating to the 1992 civil disturbances which occurred near his home. Twelve-year-old Luis, whose Santa Monica school was damaged by the January 1994 earthquake, documented Santa Monica landmarks affected by the quake. Younghee, Daniel, and Ennis lived in neighborhoods untouched by the 1993 Malibu fire but perceived it as a landmark and photographed its aftermath. While the earthquakes, fires, and civil disturbances threatened the built environment and tested the resilience of L.A.'s landmarks, they also became landmarks in their own right to the "Picture L.A." photographers.

For the first month, the photographers worked individually without meeting each other or looking at prints of their work. We minimized outside input during this initial period so that they could freely explore their own ideas, gain confidence, and avoid overly influencing each other. Later, we came together as a group five times in a series of critiques and field trips. During the critiques, the photographers shared stories about their experiences in the field and were intrigued by each others' landmarks. Together, we observed recurring themes in the pictures such as graffiti, automobiles, and fences. Abbey and Raul suggested that the repetition of fences in the pictures was their way of saying that as kids, they felt left out (it's a boundary that says Do Not Enter, Raul explained). Landmarks such as the beach were discovered as communal; seeing one person's beach photographs reminded others that it was a landmark they wanted to document, too.

In addition to our own pictures, we looked at the documentary and street photography of Robert Frank, Garry Winogrand, and Walker Evans, among others. We discussed composition, use of the frame, and the unusual ways these artists captured their subjects. Part of the project's goal was to encourage kids to consider the role of people within the physical landscape. We talked about what people could reveal about a place, and what the places could show about the people who lived there. In the following weeks, I could see the influence of these discussions in the young photographers' work.

6

We also organized field trips to some of L.A.'s designated landmarks to raise awareness among the photographers of places that reflected the city's history and culture. During the course of the project, the photographers grew more interested in previously unfamiliar historic landmarks. By the time we visited the Bradbury Building and Union Station as a group, Daniel and Raul had already photographed these places on their own. There was also some overlap between designated landmarks selected for field trips and personal ones. Sabrina lived near the Watts Towers and was a student at the Watts Towers Arts Center. Her careful, intricate photographs of the sculpture introduced us to the site weeks before we visited it as a group.

As the project progressed, the photographers developed strong ideas and feelings about their landmarks, as well as distinct visual styles with which they captured them. By the final weeks, I could usually distinguish a Younghee picture from an Abbey one, an Osofu from a Luis.

One of my greatest pleasures in the project was seeing the vision of Los Angeles that emerged as I began editing over five hundred rolls of film. For me, the whole of this work is greater than the sum of its parts, something I did not fully appreciate until we completed the final selection and sequence of images. The resolve and thoughtfulness with which the photographers approached this project (as though conscious of creating a historical document) came through in their interviews, project diaries, and our group discussions. The words that accompany their pictures here were selected from these sources.

"Picture L.A." is a photographic document of Los Angeles in the fall and winter of 1993/94, as interpreted by eight young people with diverse and unique perspectives. It is not intended as the definitive word on the city or its landmarks. Ideally, it will inspire further inquiry into what our living landmarks are: the places or events through which we define ourselves and our communities. I hope that the viewers of this work learn as much as I did about patient, honest seeing, and about the worlds of these eight photographers. I am grateful to each of them for bringing us into their homes, their communities, and their special places.

Lauren Greenfield
Director of Photography
"Picture L.A."

What's a landmark?
I think it is something

that you see everyday and

it's there and will never

disappear. It's like a part of you.

It represents you and where

you live and how you live

and what area you live in and

the people that live around there.

It also can represent something

beautiful, something that you

never really see and you never

really feel until you see it—

and it totally changes you. RAUL

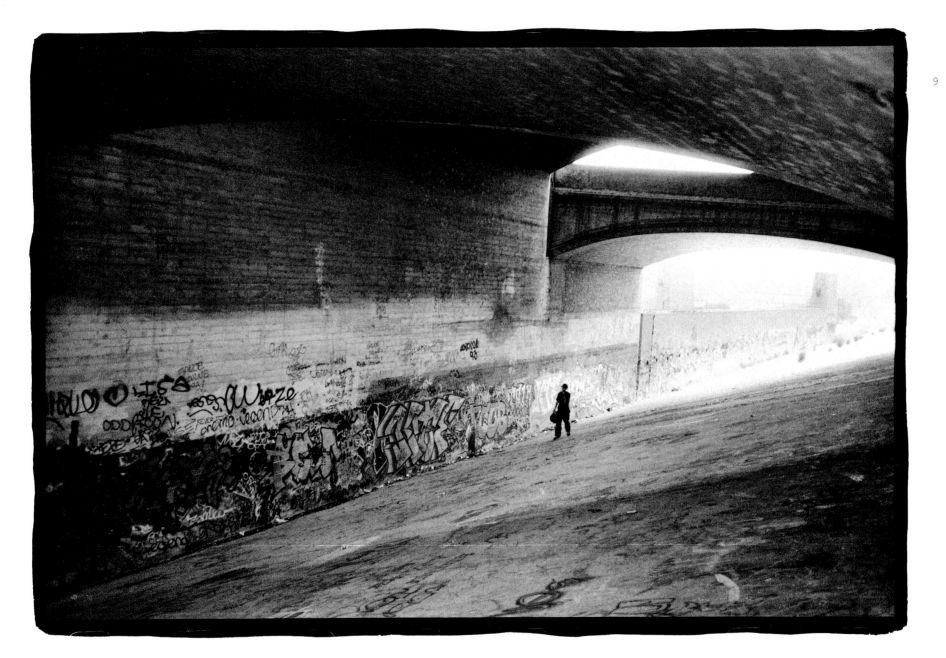

Abbey Fuchs
Los Angeles River tunnel, *Los Angeles*

10 I don't think it has to be

old — but it has to be important

for all the people. LUIS

Some landmarks are around

forever. Some are landmarks

for a very short period

of time. OSOFU

I think what makes a landmark

is something that people think

is a landmark. A place special

to them. SABRINA

A landmark is different for everyone.

I think it's something you have

grown up with and seen all of

your life. ABBEY

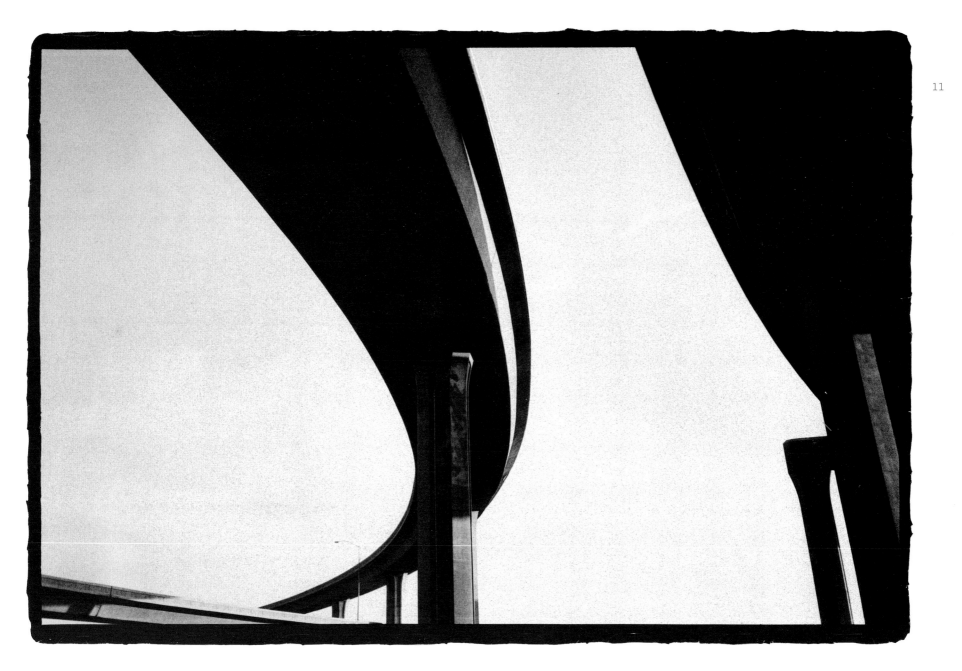

Sabrina Paschal, Century Freeway on opening day in October 1993, *South Central Los Angeles*

12

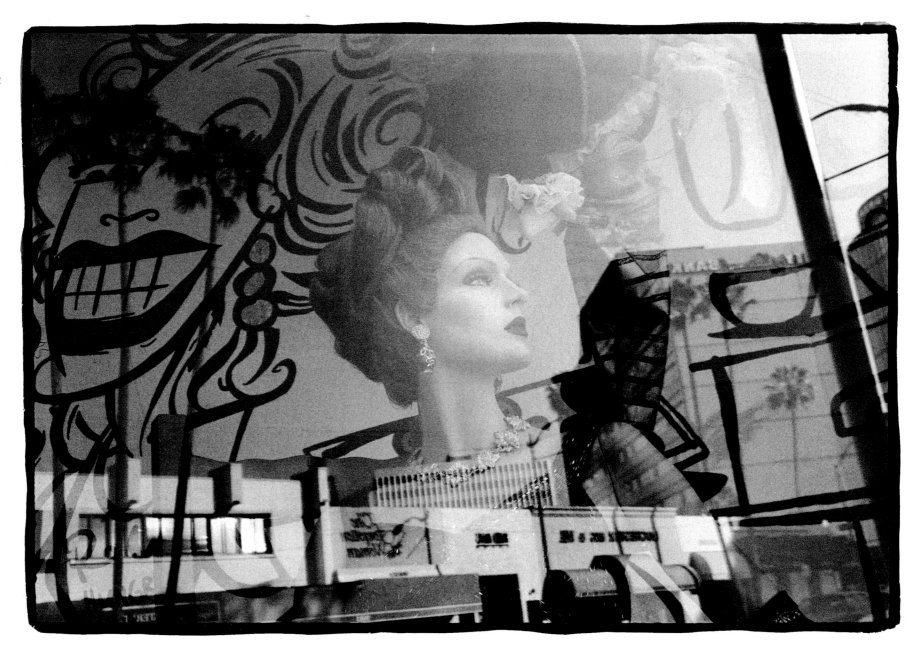

Younghee Seo
Wilshire Boulevard, *Beverly Hills*

Ennis Beley Wilshire Place, *Los Angeles*

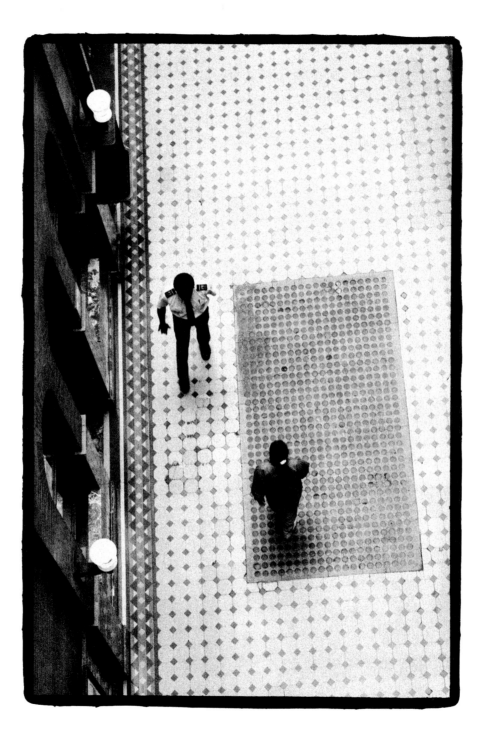

Younghee Seo
The Bradbury Building, *downtown Los Angeles*

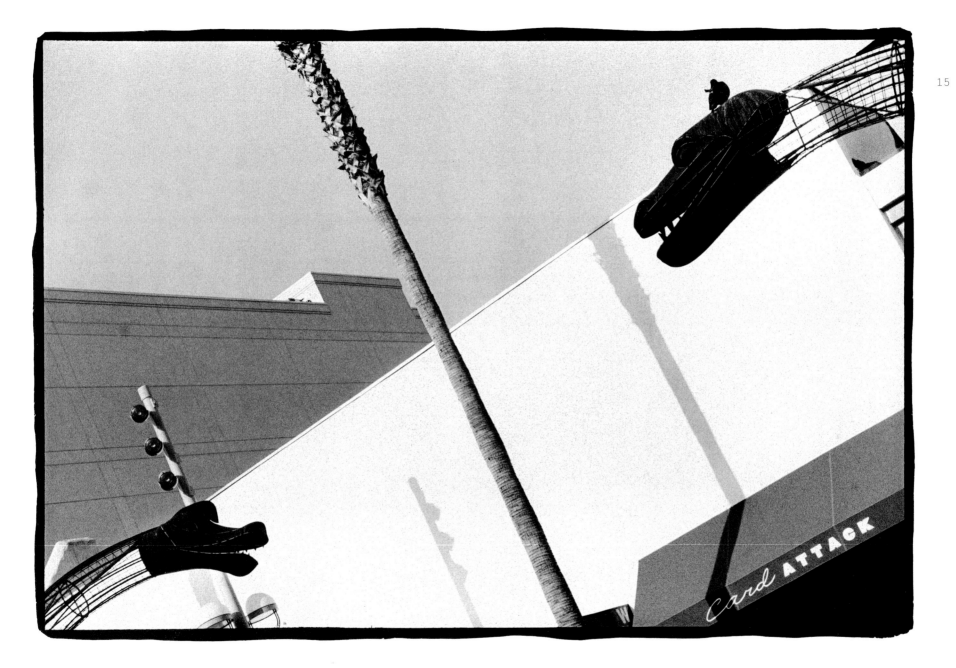

Luis Castro Third Street Promenade, *Santa Monica*

16 I woke up early to get to Hollywood Boulevard when not many people were there. In fact only a few tourists, the crazies, and I were up at that hour. I have walked on Hollywood Boulevard at all hours of the night but nothing was as eerie as that morning. Walking down the boulevard with no one else there, I felt as if everyone had died and I was the only one to survive. Something about these streets and alleys in the daylight was creepy.

 I had walked up and down many times, but today I discovered nooks and cranies I had never seen. I walked by a man shining shoes at 9:30 on Saturday morning. As he shined the shoes, the sounds of jazz came from the radio he had by the wall. I thought I had been transformed back to the twenties or thirties. His brush strokes matched the beat of the music and the newly shined shoes twinkled in the morning light. I'm here at 9:30 in the morning on Saturday and there's these two guys getting their shoes shined—not to go to work or anything, just to get them shined.

 Being there you think of movie theaters, but there were at least three closed-down movie theaters. The ticket booths were gated up. Theaters I had been in countless times were locked up forever.

 I went later one night when shops were closed and people were out for an evening stroll. It's very magical to walk there at night with all the lights of the movies on the ground sparkling. This magic faded when Younghee tried to take a picture of two men, one in the car, the other leaning in the window. Seeing a drug deal take place really brings you back to the reality of L.A.

 Hollywood is definitely a landmark because the one place you take everyone when they come to visit is Hollywood Boulevard. I don't know if it really shows L.A. because not that many different types of people go down Hollywood Boulevard. Now it's very Hispanic, which is fine, and it's very touristy. You don't get people who live there, you get tourists, you get buses of people coming down. But it's nice. ABBEY

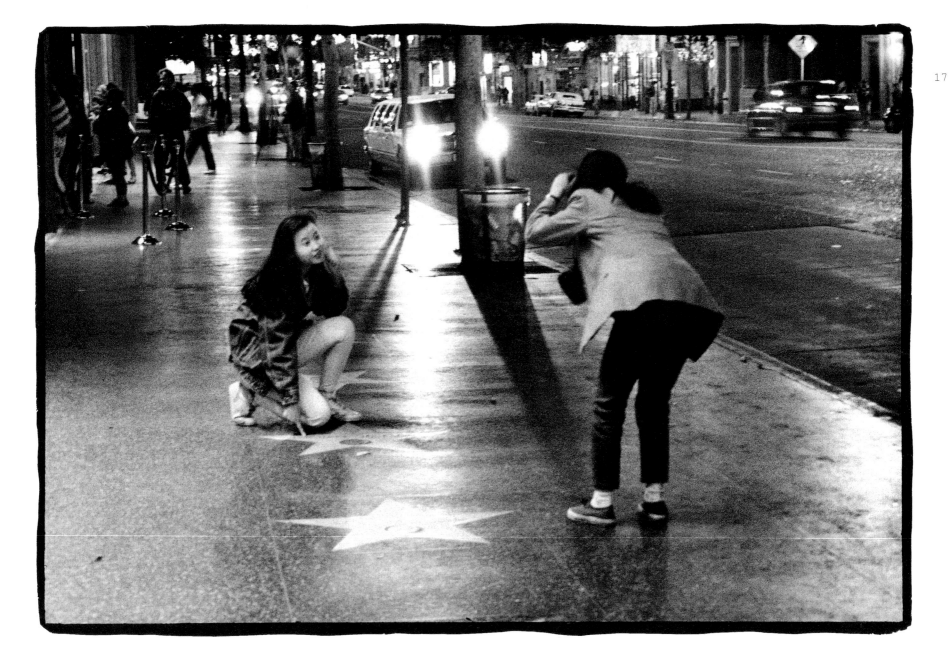

Younghee Seo Hollywood Boulevard, *Hollywood*

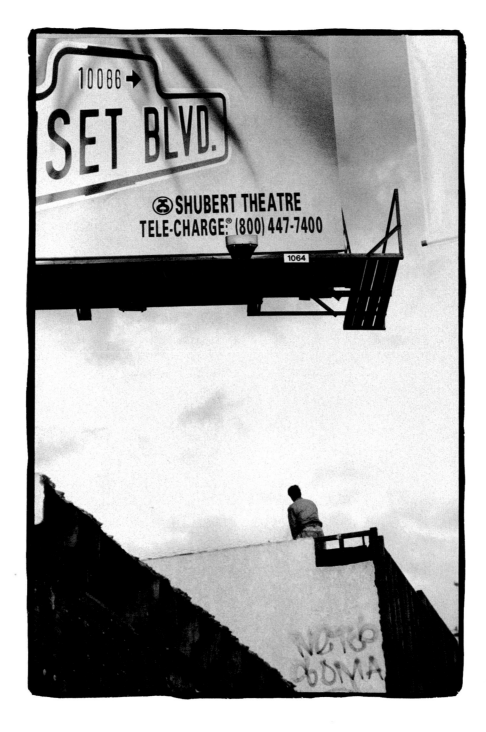

Abbey Fuchs
Melrose Avenue, *Hollywood*

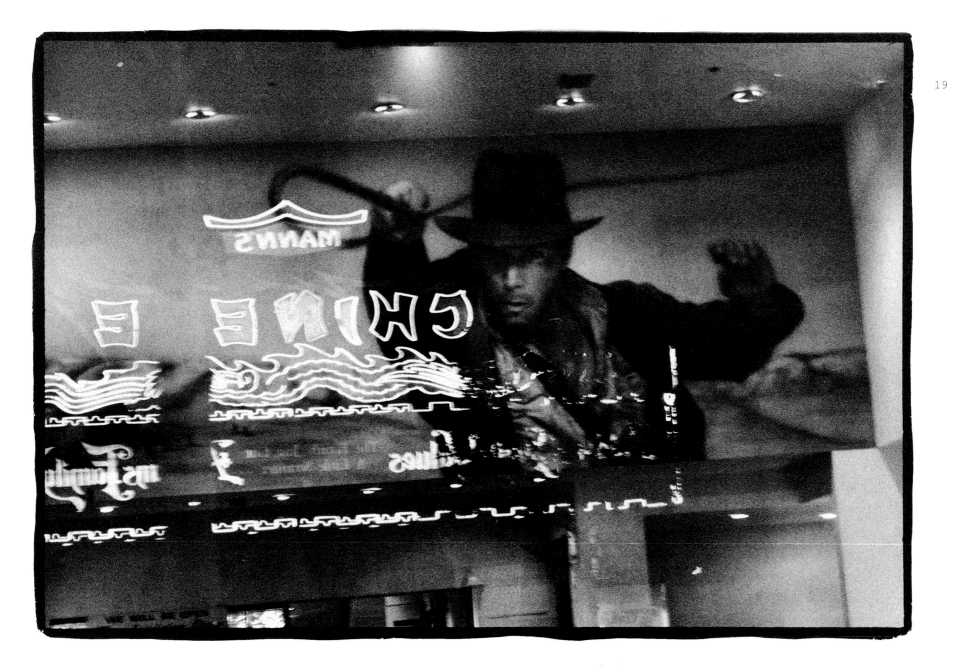

Younghee Seo
Hollywood Boulevard, *Hollywood*

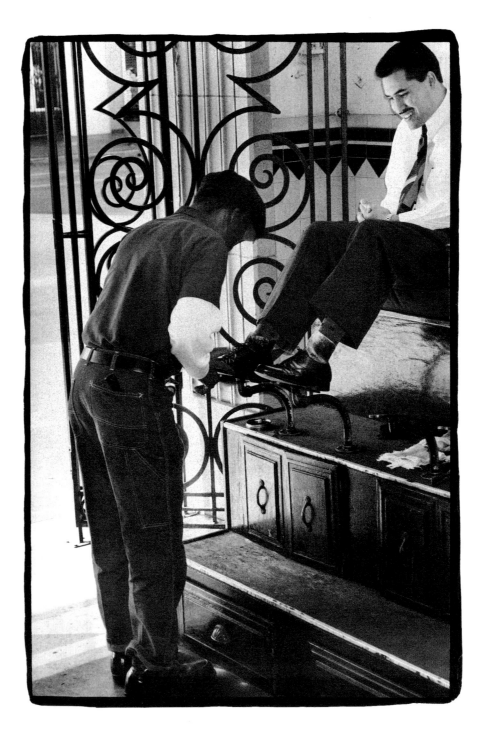

Abbey Fuchs Hollywood Boulevard, *Hollywood*

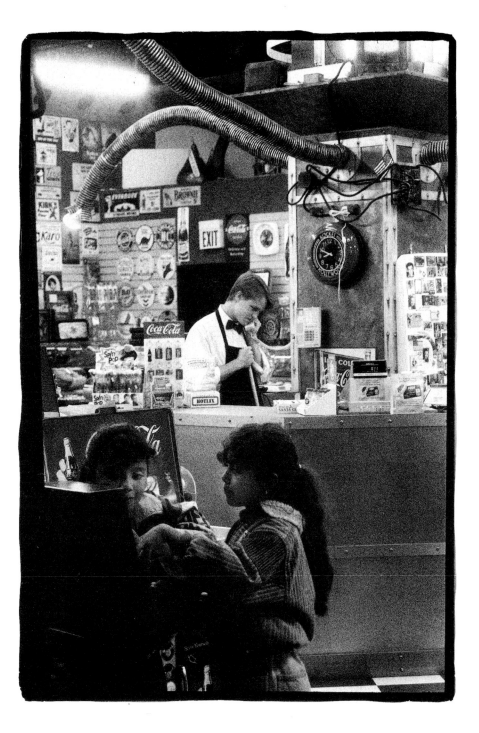

Abbey Fuchs
Rocket Hollywood candy store on Hollywood Boulevard, *Hollywood*

22

Daniel Hernandez View from the Chateau Marmont hotel, Sunset Boulevard, *Hollywood*

Younghee Seo
Swimmer at the Chateau Marmont hotel, Sunset Boulevard, *Hollywood*

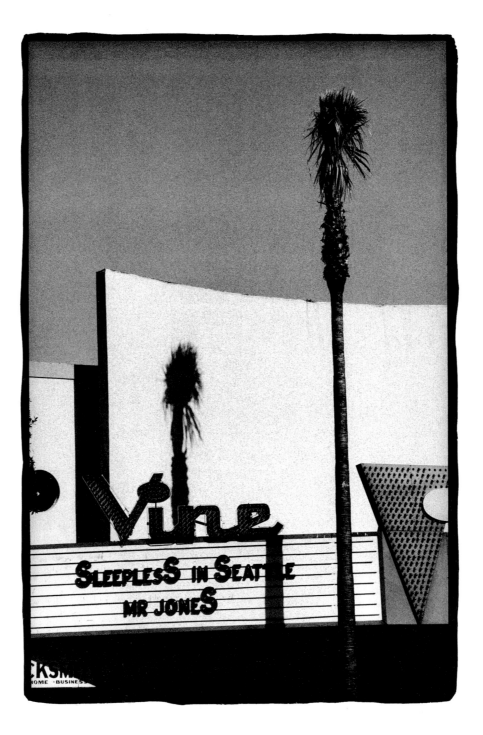

Abbey Fuchs
Vine Theater, Hollywood Boulevard and Vine Street, *Hollywood*

Abbey Fuchs Melrose Avenue, *Hollywood*

Landmarks give the feeling

of what the place is about. If

you tear them down, you will just

have this big empty space that

doesn't mean anything. ABBEY

Without landmarks there would be no history... Without history, what do you have

to look back on? Like memories.

Life is based on memories. OSOFU

We need them so we can

learn more about our history...

so we can know how the past was

so we can make a better future so

we won't make the same mistakes

they did. DANIEL When you destroy a landmark, you

destroy some of other people's

history. SABRINA

Osofu Washington
Western Avenue, *Los Angeles*

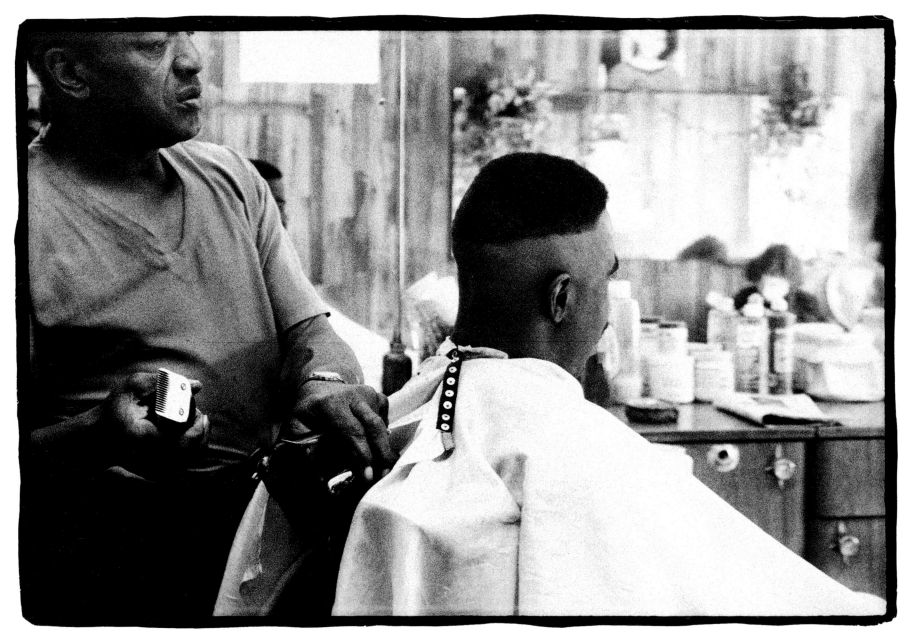

Osofu Washington
Clay's Barber Shop on Manchester Boulevard, *Inglewood*

Clay's Barber Shop is the second oldest in Morningside.

For some people, when you go to a barber, that is your barber for life. I mean, you like the style, you like the people. The old folks hang out and talk and they have a radio and TV and watch videos. It's like a place to hang out sometimes. Get a haircut, just kick it.

When we first walked in they were kind of skeptical about us. Oh my God, we don't want you to take pictures. But as we were standing there and talked to them, we had a nice little chat, a nice conversation. After a while, they got used to us.

It's given me a new outlook on my neighborhood. I never even paid attention to that barber shop until now. I didn't pay attention to the landmarks. I never had a desire to preserve things.

Now I really care about things that may not be here two years from now. OSOFU

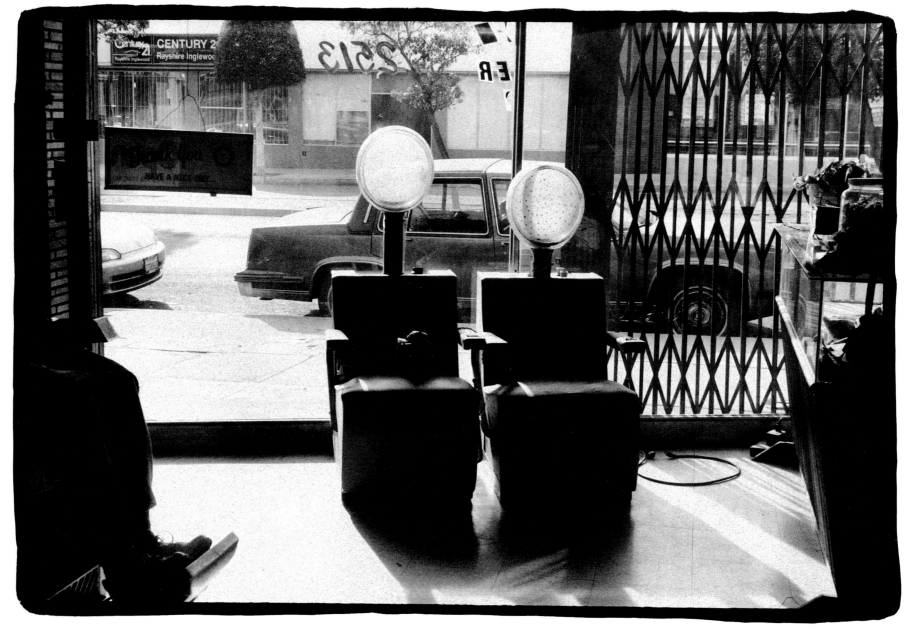

Osofu Washington
Clay's Barber Shop on Manchester Boulevard, *Inglewood*

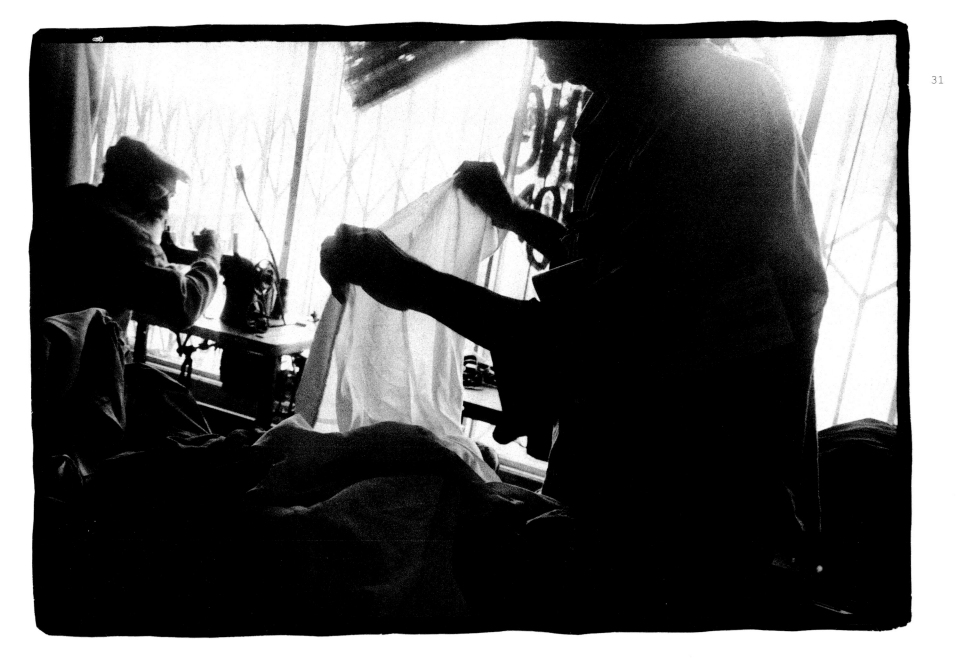

Ennis Beley
Ennis's father's dry cleaning shop, *South Central Los Angeles*

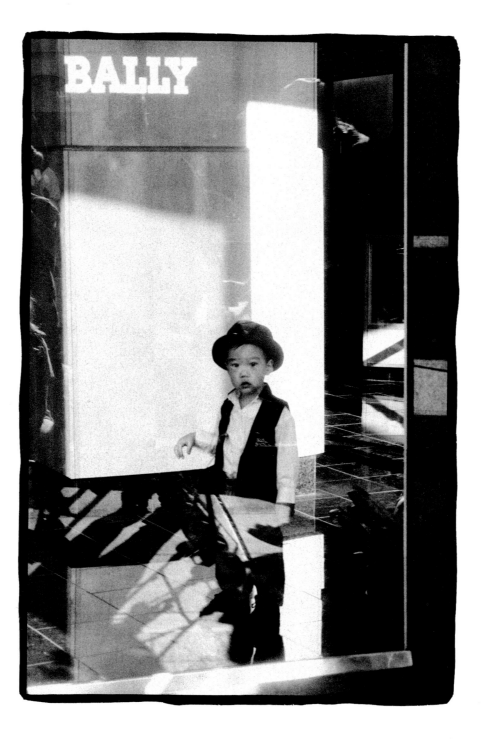

Luis Castro
Rodeo Drive, *Beverly Hills*

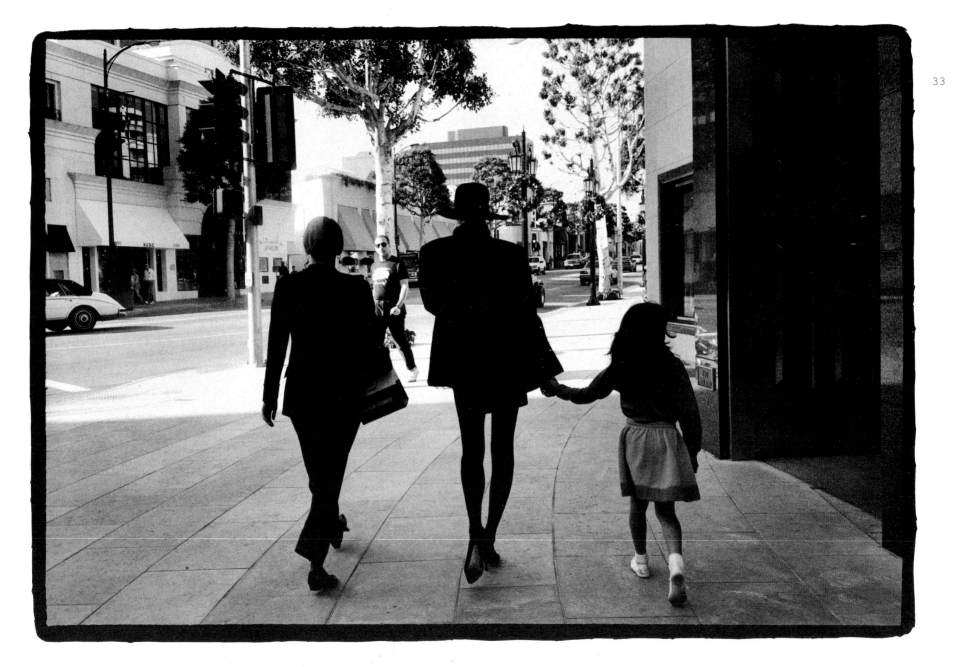

Ennis Beley
Rodeo Drive, *Beverly Hills*

34

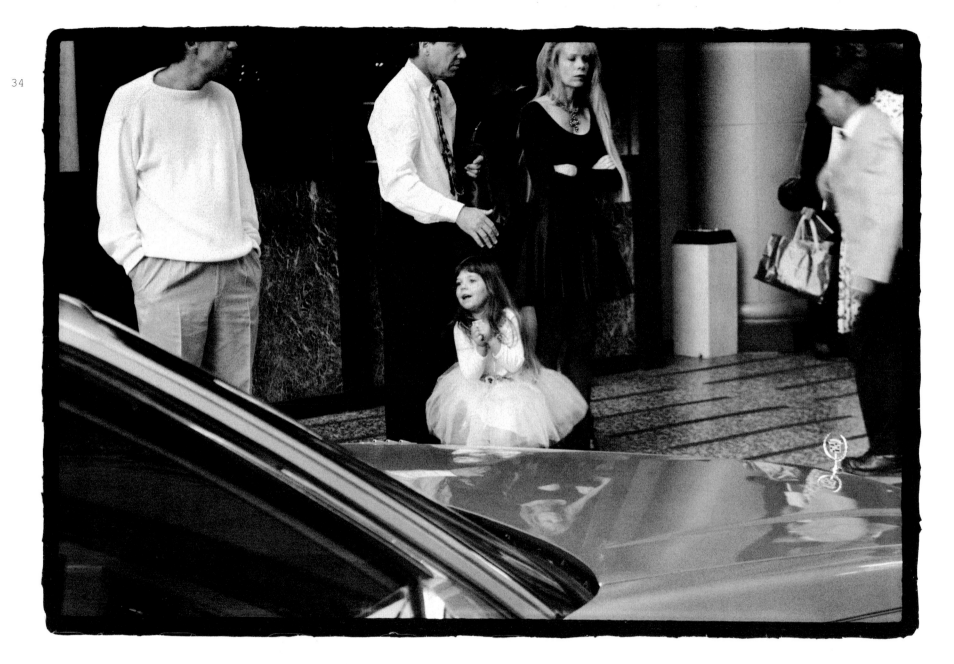

Younghee Seo
Beverly Wilshire Hotel, *Beverly Hills*

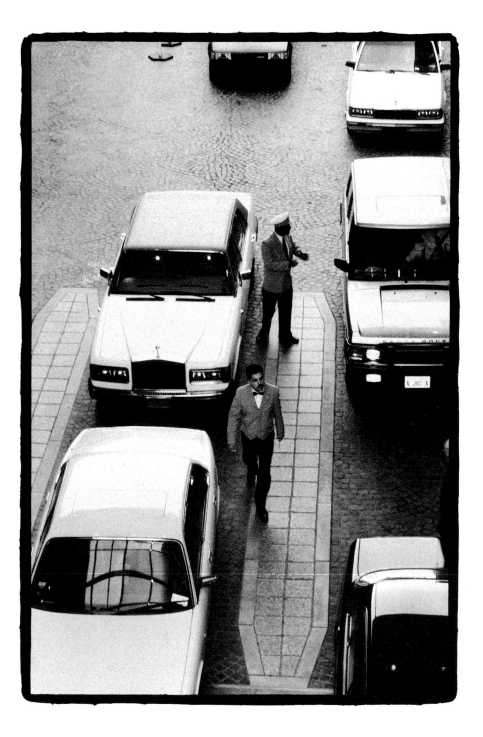

Ennis Beley Beverly Wilshire Hotel, *Beverly Hills*

36 You know you hear a lot about

Crenshaw. That's the street.

Basically everybody hangs out

Sunday nights. If you were to

drive up Crenshaw it would take

you about thirty minutes to

an hour to get from Vernon to

Florence. I mean people just hang

out on Crenshaw. Definitely a

landmark. OSOFU

In my neighborhood we don't have

the low riders. ...I never saw

the south side the way Osofu and

Ennis shot it. I was able to see

another South Central. RAUL

Ennis Beley Crenshaw Boulevard, *South Central Los Angeles*

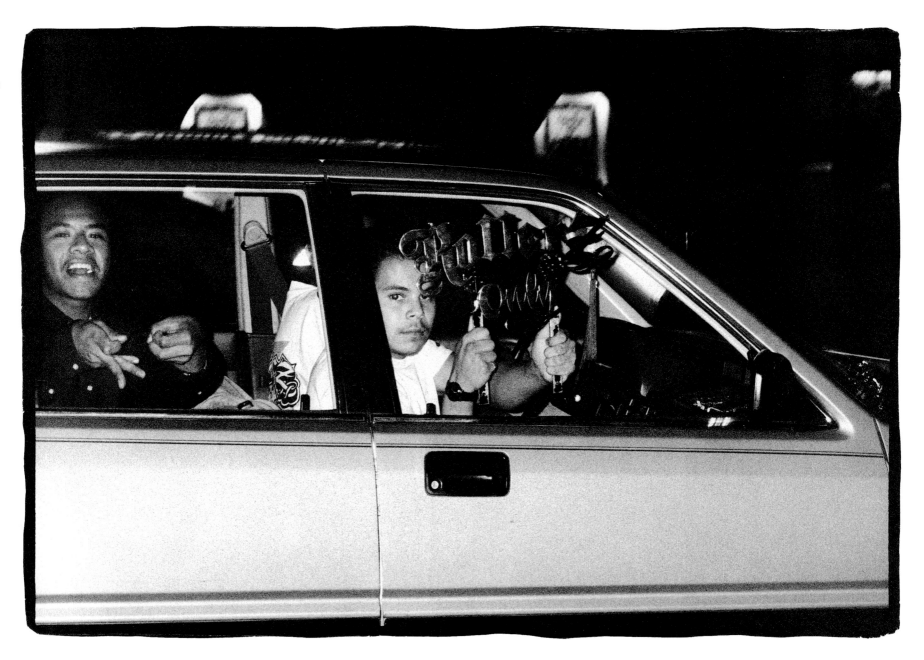

Ennis Beley
Hollywood Boulevard, *Hollywood*

Ennis Beley
Universal CityWalk, *Universal City*

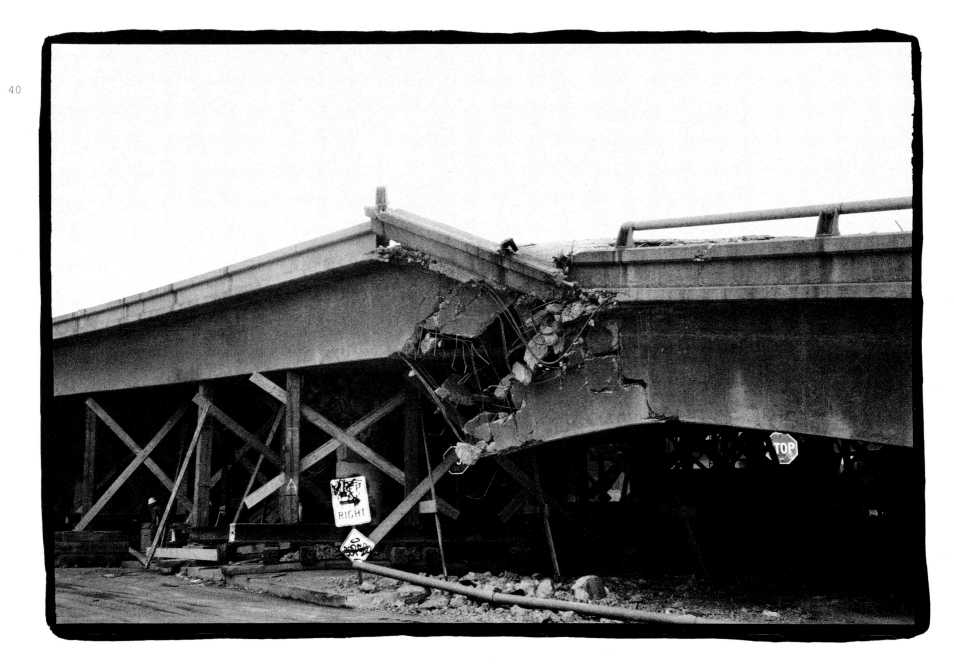

Ennis Beley
Santa Monica Freeway after January 1994 earthquake, *Los Angeles*

That is something everyone has

to remember. ...I never thought

a freeway could break from an

earthquake. I thought the freeway

would be there all the time. ENNIS

Ennis Beley
Ennis's home after January 1994 earthquake, *South Central Los Angeles*

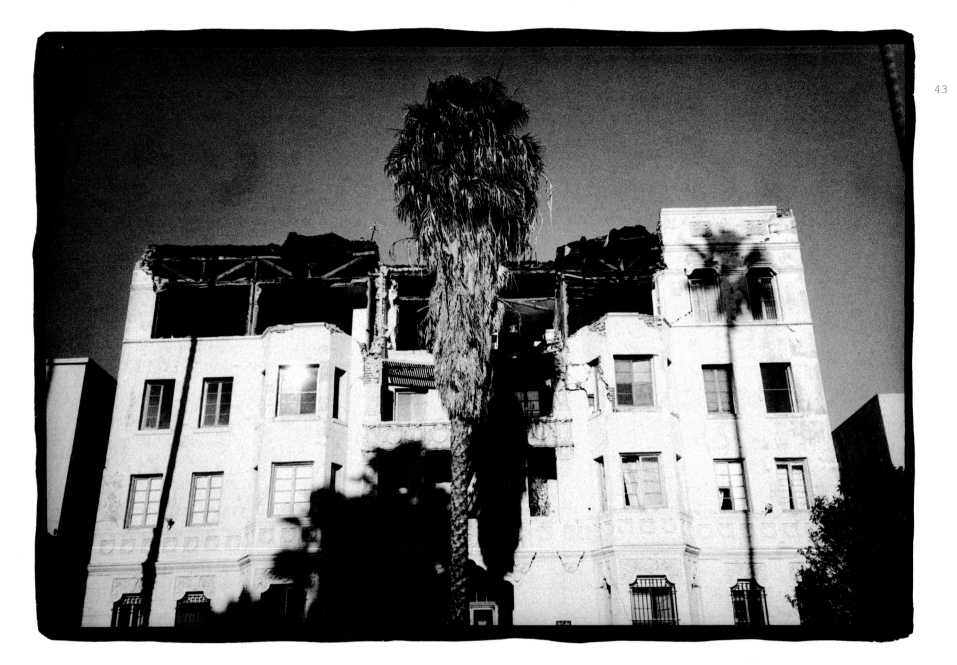

Luis Castro
El Cortez apartments after January 1994 earthquake, *Santa Monica*

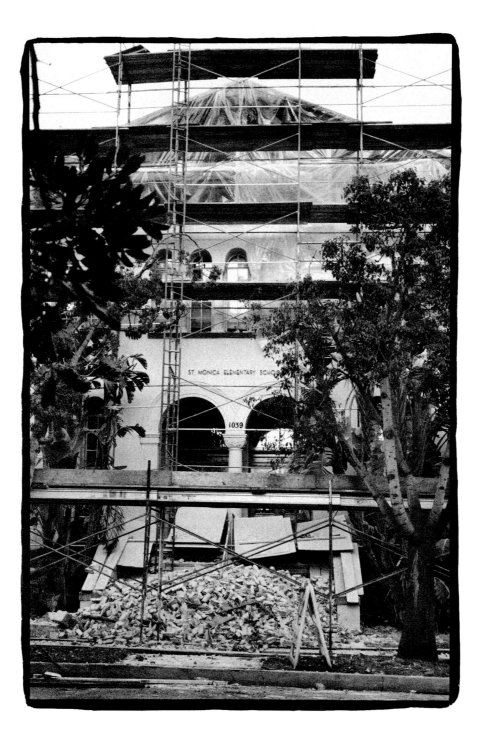

Luis Castro
St. Monica Elementary School after January 1994 earthquake, *Santa Monica*

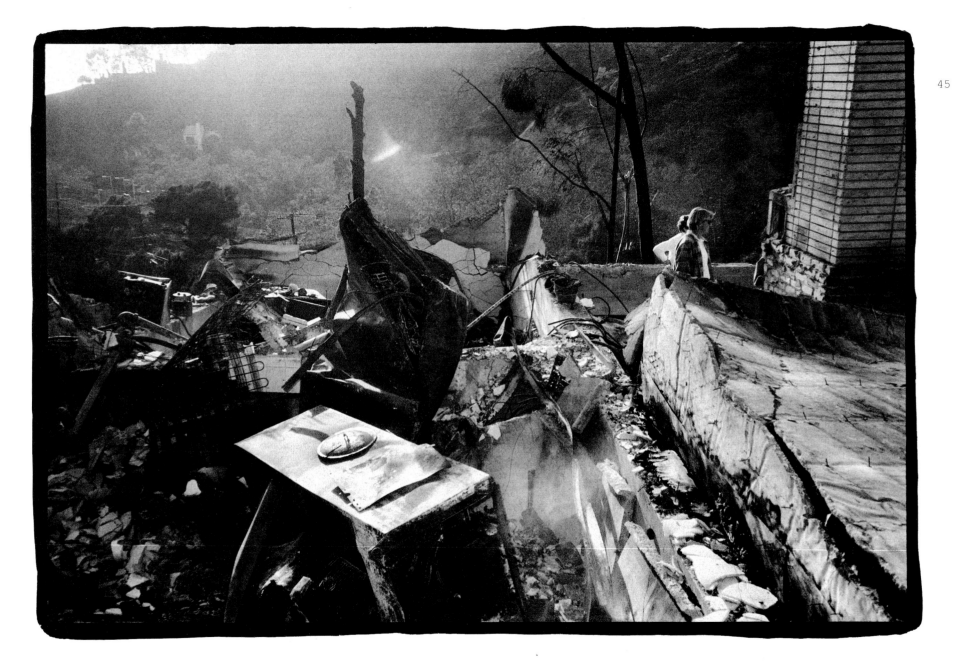

Daniel Hernandez, Las Flores Canyon after November 1993 fire, *Malibu*

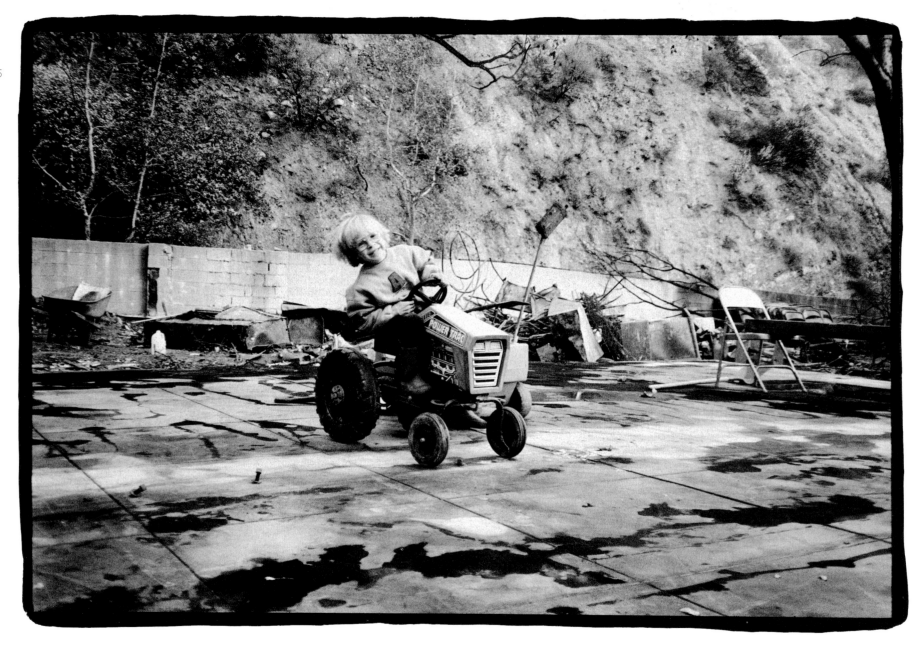

Ennis Beley Carden Malibu School, Las Flores Canyon, after November 1993 fire, *Malibu*

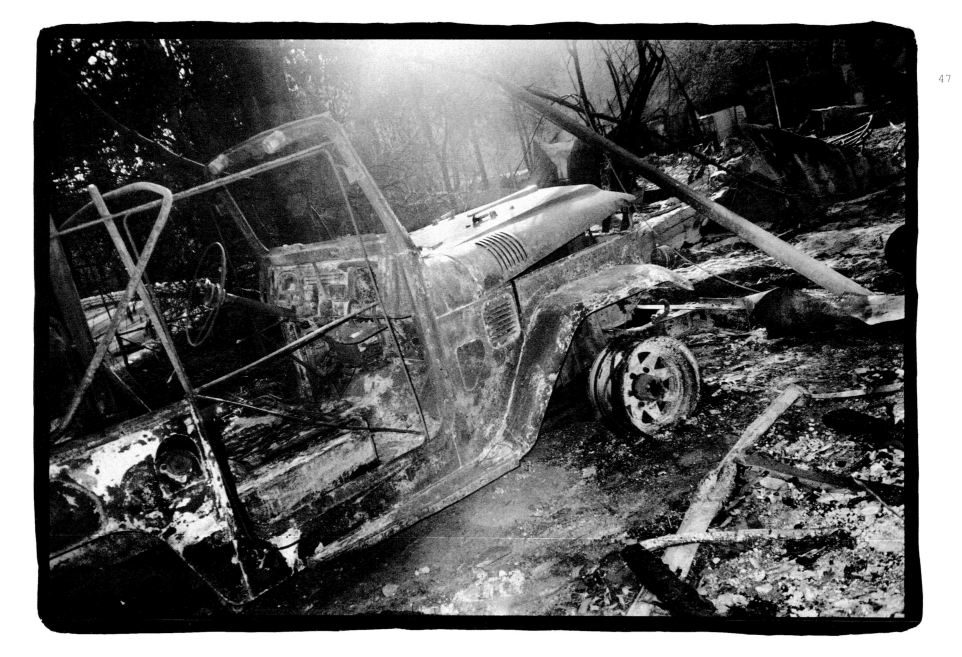

Ennis Beley
Las Flores Canyon after November 1993 fire, *Malibu*

48 This girl, Bebie, she used to say when she was a teenager, she

was a model. ...She put on lipstick and she combed and washed

her hair before we could take the picture. ...This guy named

Ralph, he's an artist and he draws beautifully. ...Tracy, he's

the guy who takes care of [the place]. He's a good guy. ...They

don't permit drugs. They say no drugs, you can't have drugs. If

you have drugs, you are out. ...The Belmont tunnel is dark and humid and dirty,
but there are people here that call this home.

It looks like a real home but with graffiti on the walls and

with holes in the ceilings which was the only light they had

in there.

Both the building and the people are landmarks. The building

because of its artwork and design and its structure and the way

it's kept, and the people because they're the ones that live in

it and the ones that created it. RAUL

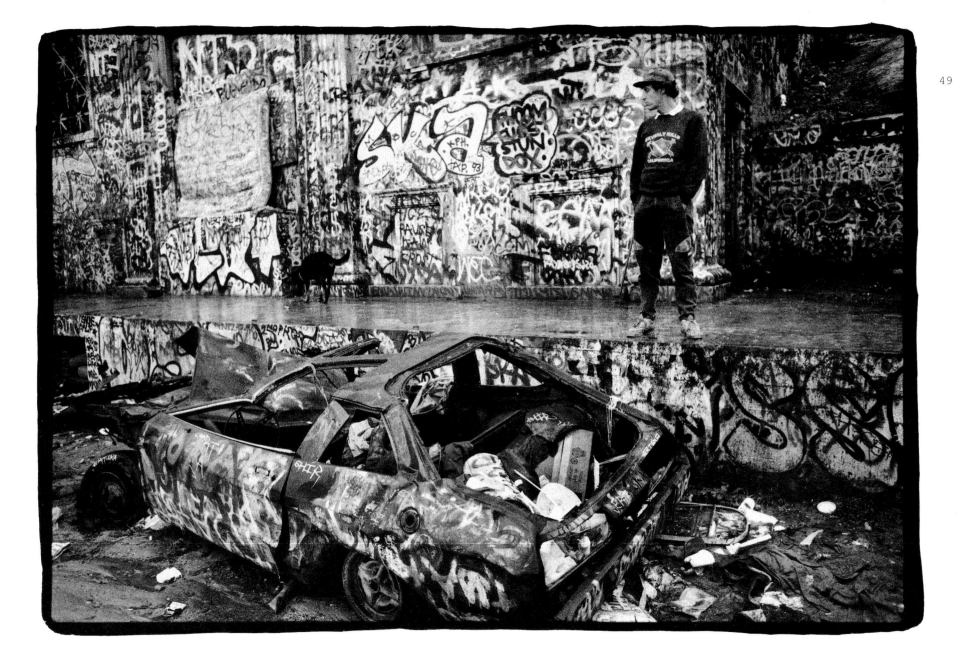

Raul Herrera
Belmont tunnel, *downtown Los Angeles*

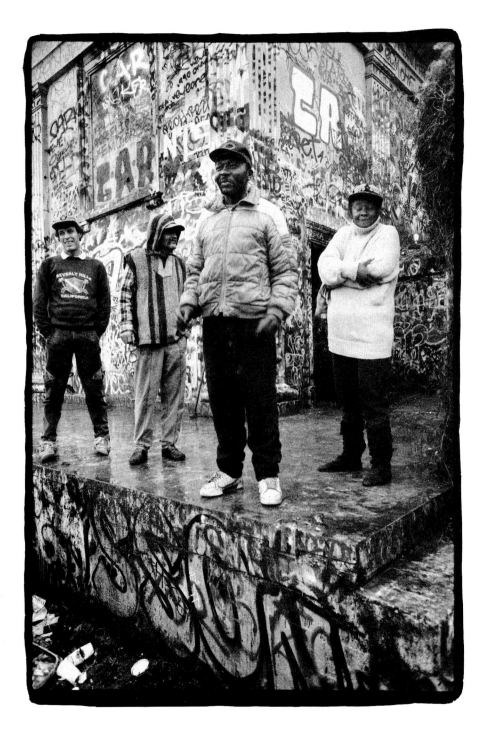

Raul Herrera
Belmont tunnel, *downtown Los Angeles*

Raul Herrera
Belmont tunnel, *downtown Los Angeles*

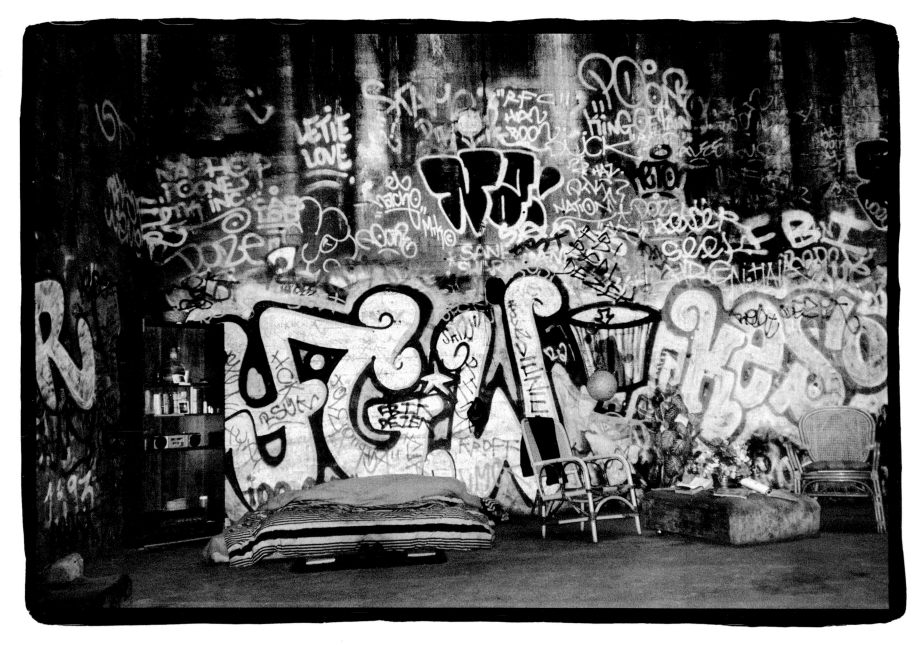

Raul Herrera
Belmont tunnel, *downtown Los Angeles*

Inside the building, they

have their own home—their

rocking chair, their bed,

their shelf with their books

and their magazines, their

desk, their flowers, their

lamps. ...It's just walls made

out of graffiti and pieces

of tagging and flowers next

to it. Many people go by it, but not many go inside. RAUL

The homeless are everywhere, you know.

You see homeless in every part of town, in every corner, in every freeway, everywhere. RAUL

I think adults try to filter out homelessness and those who are down on their luck.

As young people, we have not seen it as long as they have.

It's more fresh to us and we are really seeing it much more than they are. ABBEY

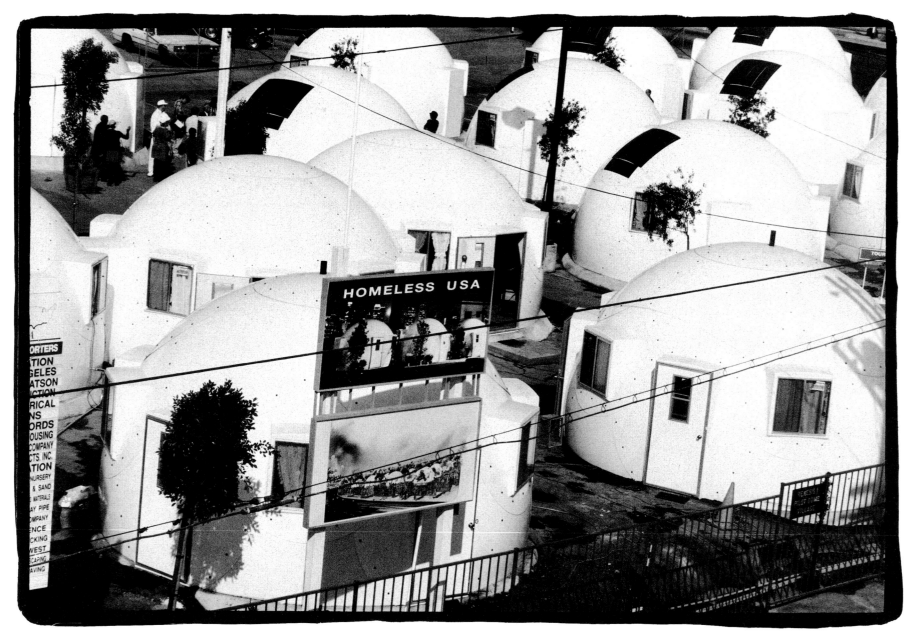

Ennis Beley
Genesis 1 housing project, *downtown Los Angeles*

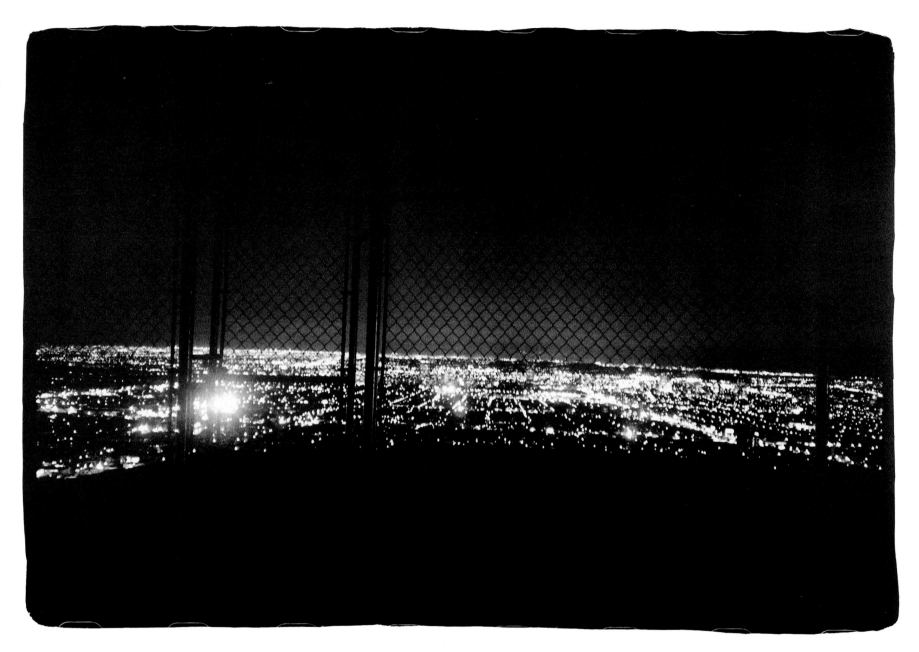

Abbey Fuchs
View from North Curson Avenue, *Hollywood*

We drove to an outlook I know about.

When we got there, we realized we didn't have a tripod

and that it would look better at night.

So we came back one night and a fence had gone up blocking the view.

We decided to take the picture anyway. ABBEY

Sabrina Paschal
Century Freeway, *South Central Los Angeles*

Sabrina Paschal
Century Freeway from Imperial Highway, *South Central Los Angeles*

ONE WAY

There were so many places I wanted to photograph

that were close but yet so far.

You just couldn't walk around the neighborhood

because they think you are a gangster.

I couldn't go to Western and Normandie,

I couldn't go to Vermont

'cause that was White Fence hood.

I couldn't go to Pico

because that was Playboy hood. ...

I couldn't go to Hoover

because of the Hoover Locals

and I couldn't go to Echo Park...

just everywhere. RAUL

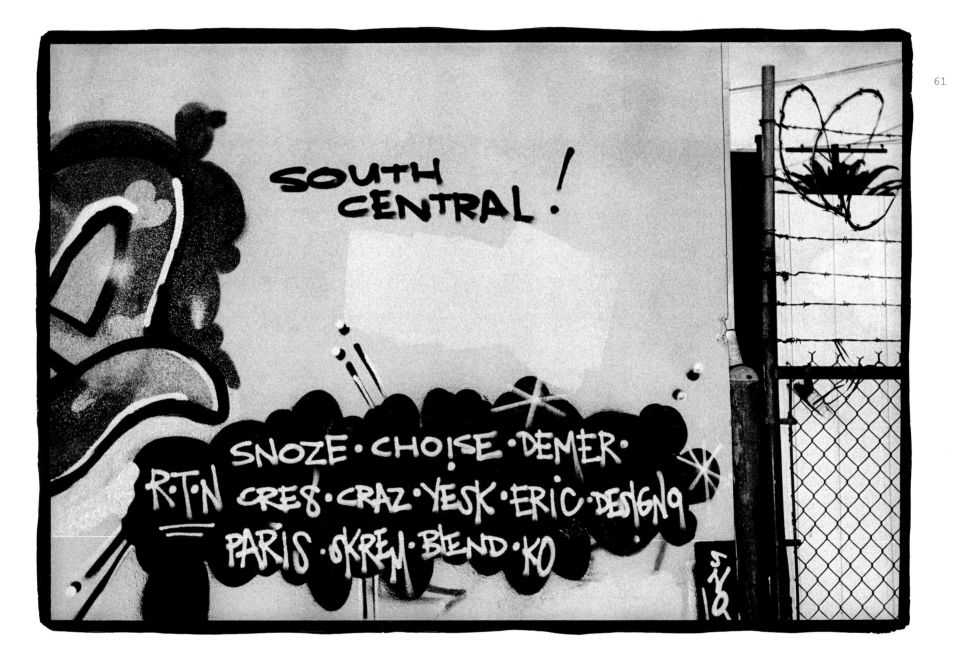

Ennis Beley
54th Street and Western Avenue, *South Central Los Angeles*

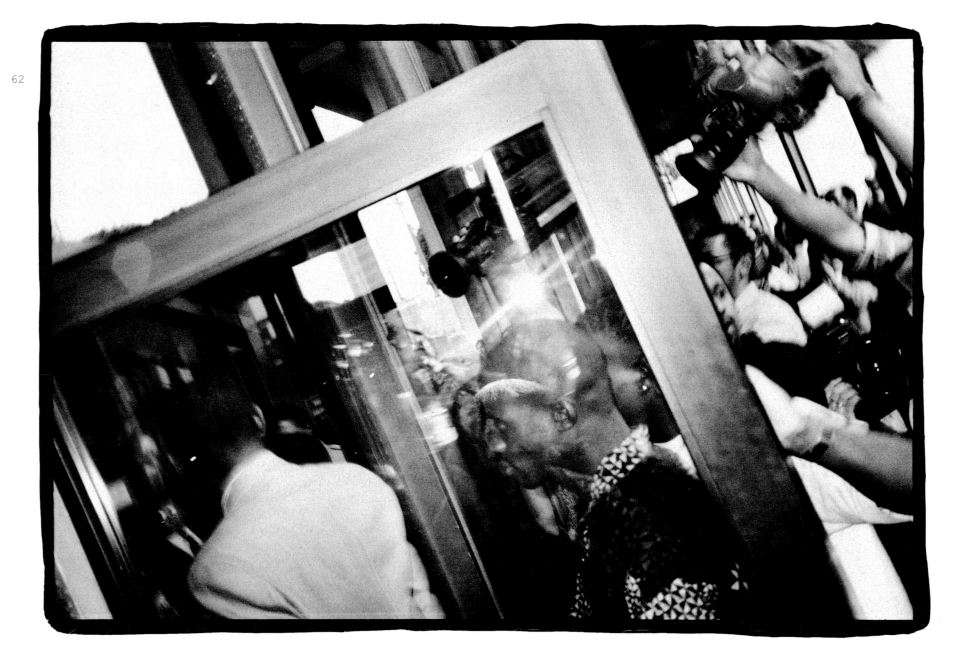

62

Ennis Beley
Criminal Courthouse, Reginald Denny beating trial, *downtown Los Angeles*

Florence and Normandie is a landmark.

That's where Reginald Denny got beat up.

That's where the riots broke out.

That's where the first store got looted.

Across the street from me is this store named Kwan's Market.

It got burned down.

There was a store on the corner that got burned down.

The liquor store on 60th and Normandie, that got burned down and the fish market got looted.

The barber shop got looted and the wash machine place got looted.

I seen people getting beat up, people shooting at the police cars.

People burning down stores. ENNIS

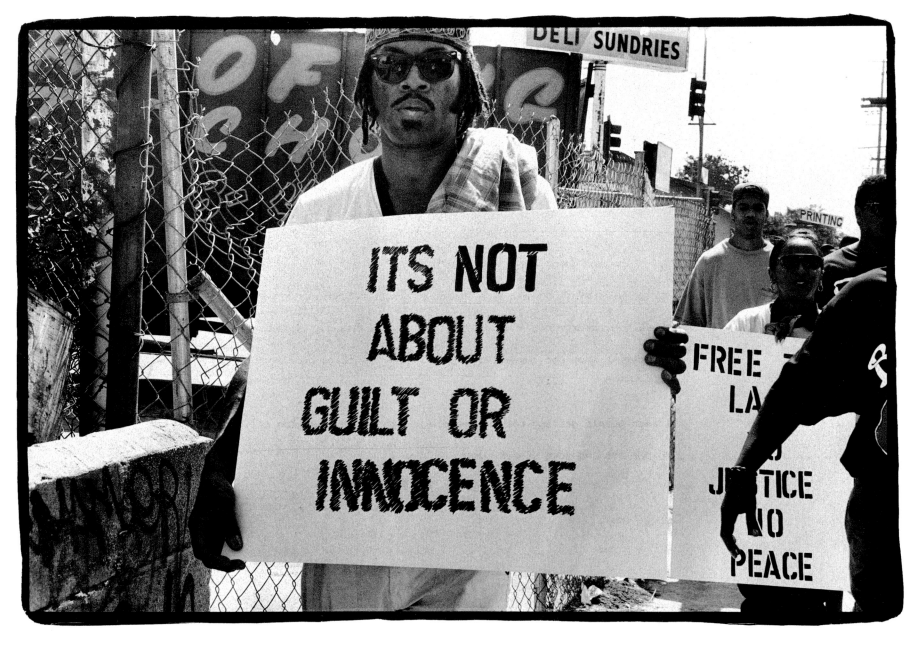

Ennis Beley
San Pedro Street during the Reginald Denny beating trial, *South Central Los Angeles*

Ennis Beley Empire Liquor Market on South Figueroa Street two years after Latasha Harlins was killed by the store owner, *South Central Los Angeles*

66 I just saw these two persons

sitting there looking out

at the ocean. They looked like

the only persons in the

whole world. LUIS

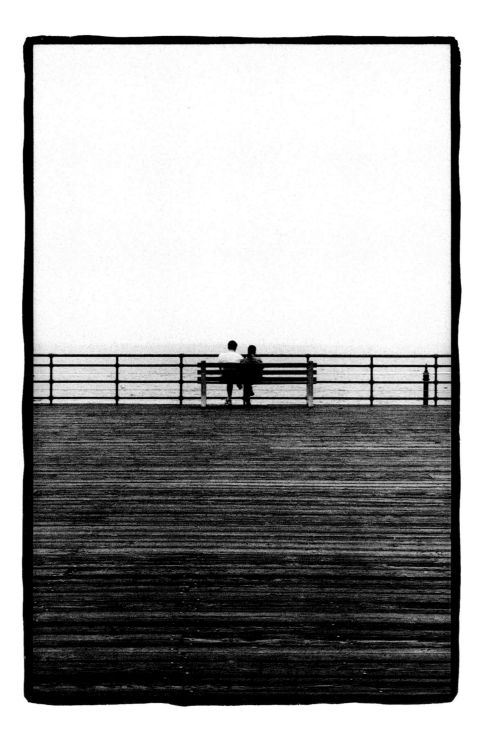

Luis Castro
Santa Monica Pier, *Santa Monica*

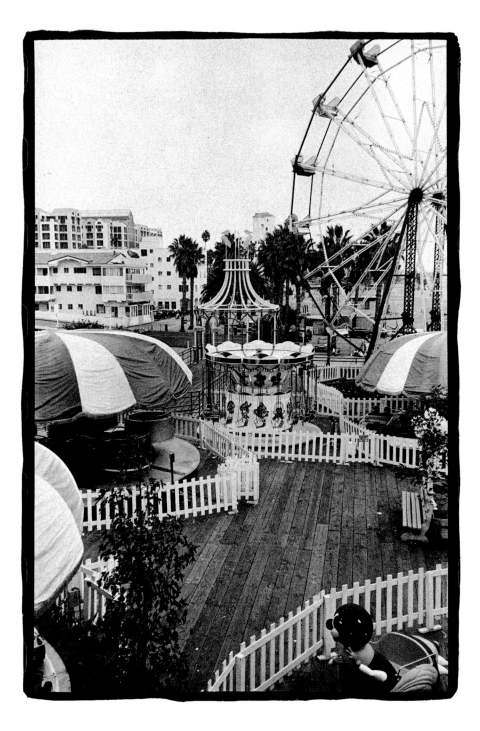

Luis Castro
Santa Monica Pier, *Santa Monica*

Abbey Fuchs
Santa Monica Pier, *Santa Monica*

This is the last place on the pier that sells fish.

It's been there forever.

Every other place sells ice cream and french fries now. ABBEY

Abbey Fuchs
Santa Monica Pier, *Santa Monica*

I think that a landmark is to show the life of the people. YOUNGHEE

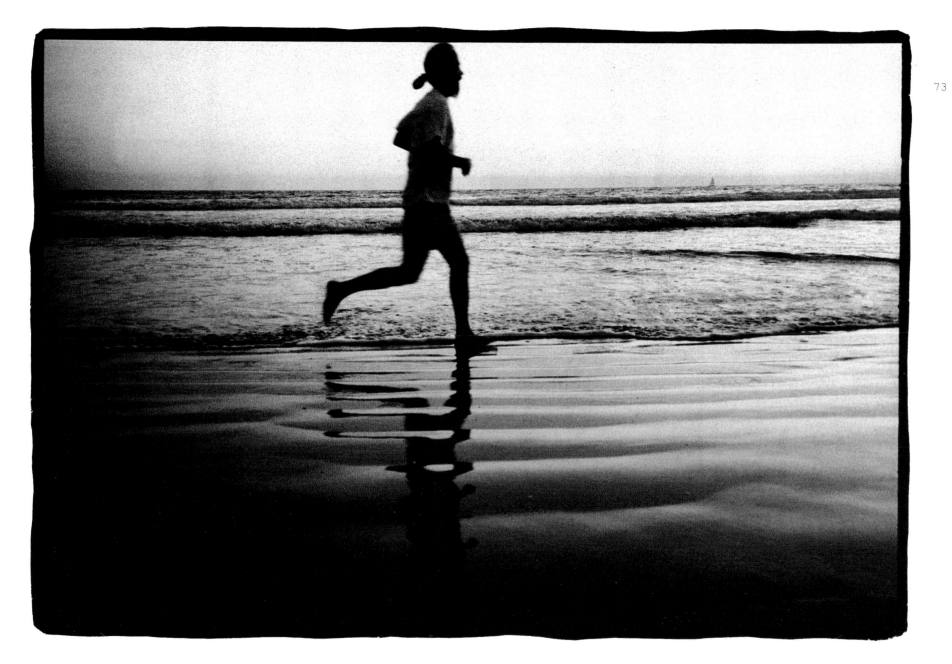

Osofu Washington
Venice beach, *Venice*

74

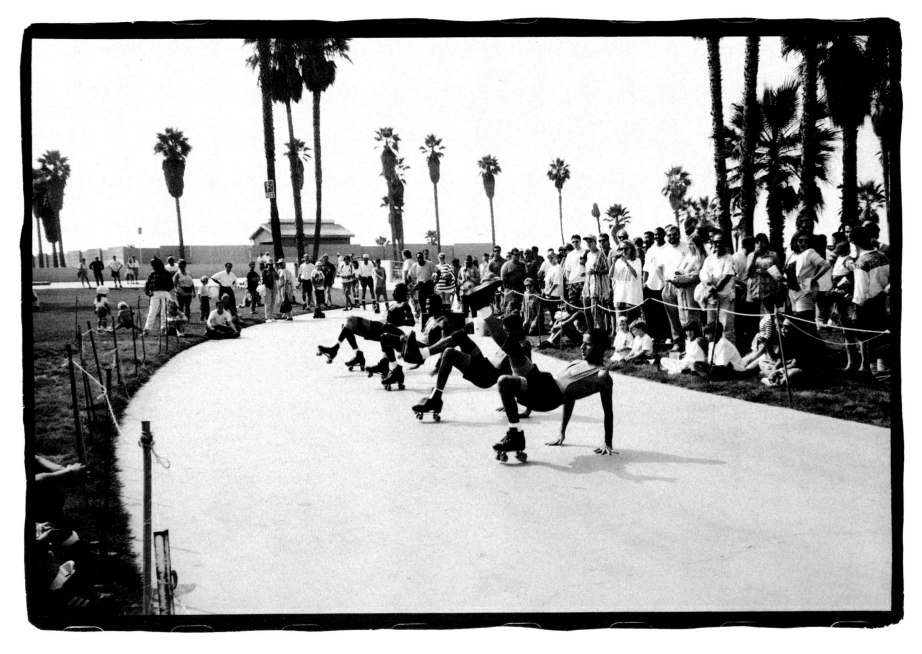

Ennis Beley Venice boardwalk, *Venice*

Younghee Seo
Santa Monica beach, *Santa Monica*

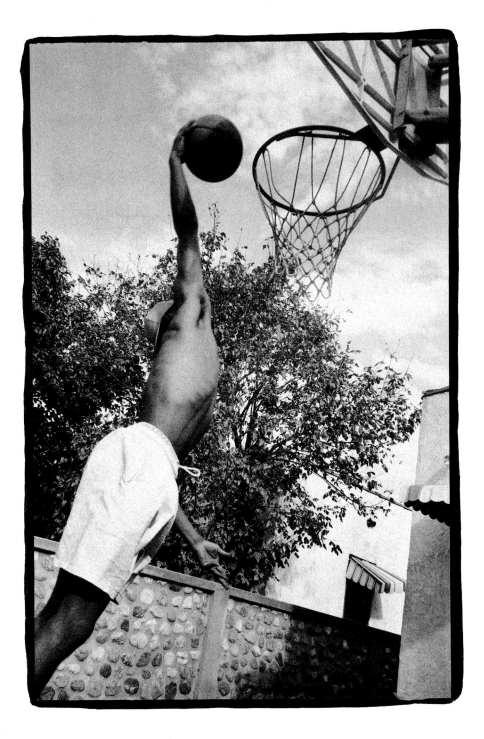

Osofu Washington
Osofu's backyard, *Inglewood*

I just love basketball.

So I figure landmarks and basketball—

I just related the two. . . .

Here's one at my house.

Everybody has some form of landmark.

Everybody has some place that they can refer to like,

"Yeah, that's where we were back then." If people

can understand our landmarks, they can see things

from our point of view. OSOFU

The landmarks in my community

are the Watts Towers, the Watts

Health Foundation, Markham Junior

High, City Hall, the Watts Library,

Will Rogers Park, Martin Luther

King Shopping Center, the Hacienda

Projects, the Nickerson and the

Jordan Downs Projects. ...

Sabrina Paschal
Watts Towers, *Watts*

There is more to the Hacienda

Projects than just shooting

and gang banging. ...Most of

the time the news media make

it seem like it's such a bad

place that no one should go

there. They make the whole

neighborhood seem bad.

Even though I live around the

projects, that don't mean I'm

a baybay kid—a bad kid. ...

You know how most people will

say that most kids who live

around the projects are bad

and want to beat you up and

stuff—but most of them are

not like that. SABRINA

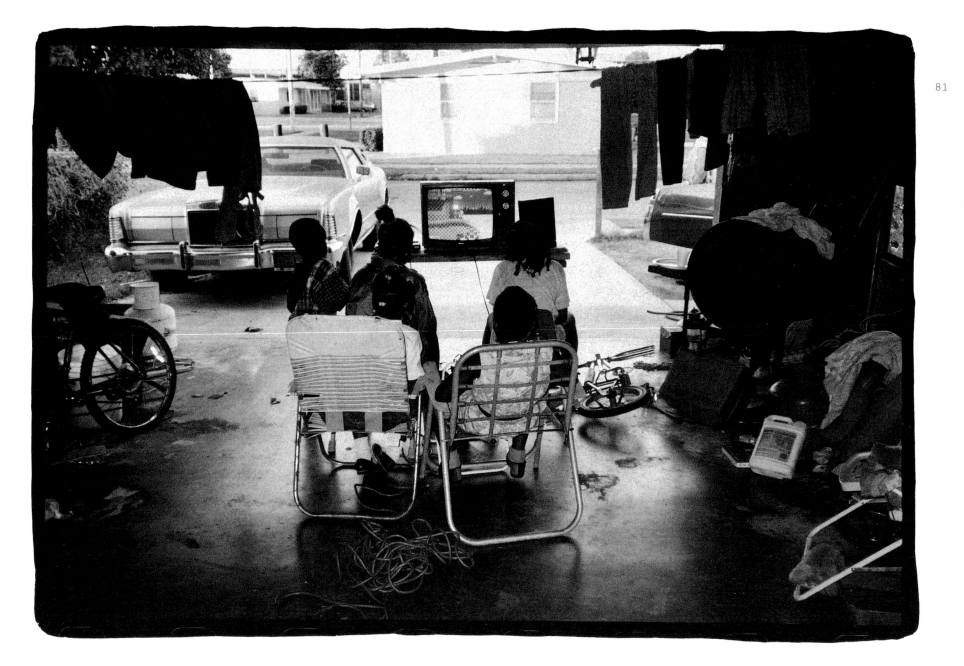

Sabrina Paschal
Sabrina's garage on Thanksgiving weekend, *Watts*

There is an old Korean temple. A lot of very old Korean people go there...many old people who just came from Korea.

When I see them, I feel a lot of things. I can see how their lives go because they have it harder here. YOUNGHEE

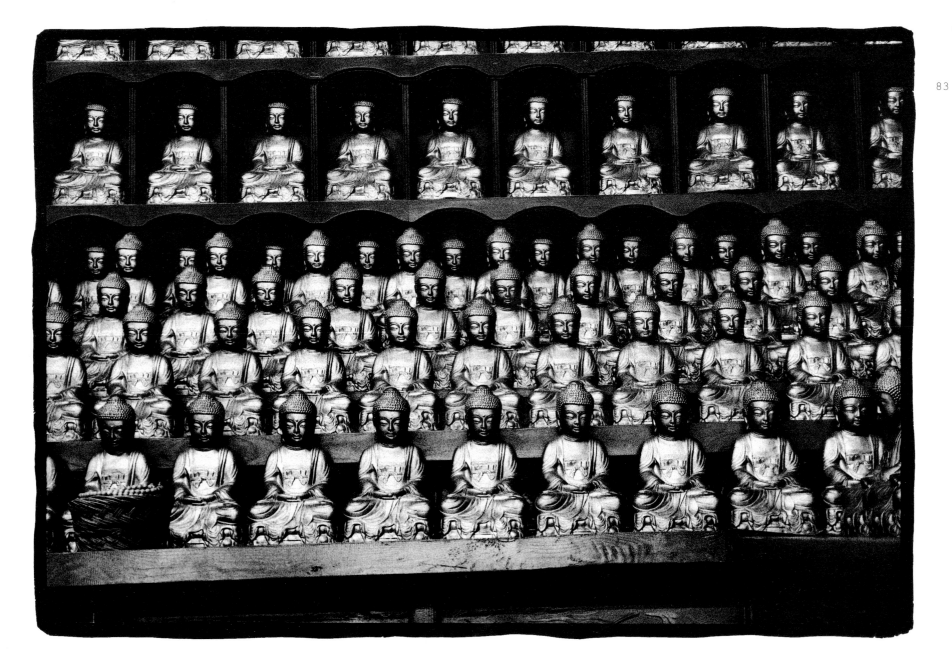

Younghee Seo
Los Angeles Dal-Ma-Sah Temple on Wilton Place, *Koreatown*

84 I look around my neighborhood

and see houses that have changed.

One that has been around for

maybe seventy-five, eighty years,

I say to myself, that's a landmark.

That was here then, and it's still here.

I look at potential landmarks —

like new churches. I just feel

my eyes have been opened to

new and different things. OSOFU

Osofu Washington First Church of God on Crenshaw Boulevard, *Inglewood*

86 From my pictures people could learn that all I want to do is help

the community and see it stand for my children, my grandchildren,

and their children so we can have a restful place. No more drivebys,

shootings, or accidents or highway crashes....I would like to show everybody the historical
landmarks and how they can help us, so we can save
them and they won't be junked up and mess up the
children's future. DANIEL

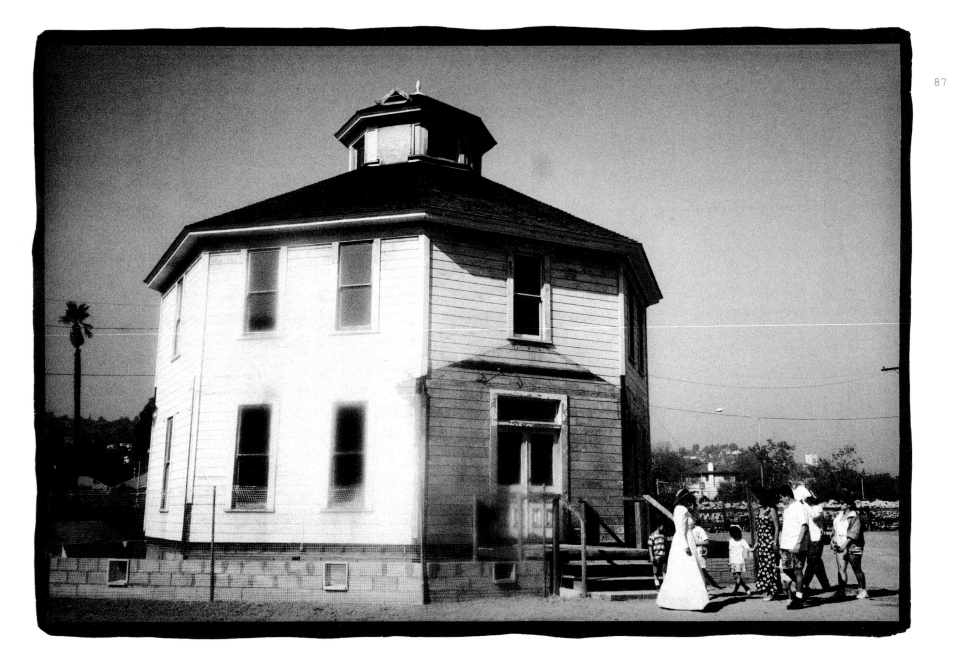

Daniel Hernandez
Octagon House, Heritage Square, *Montecito Heights*

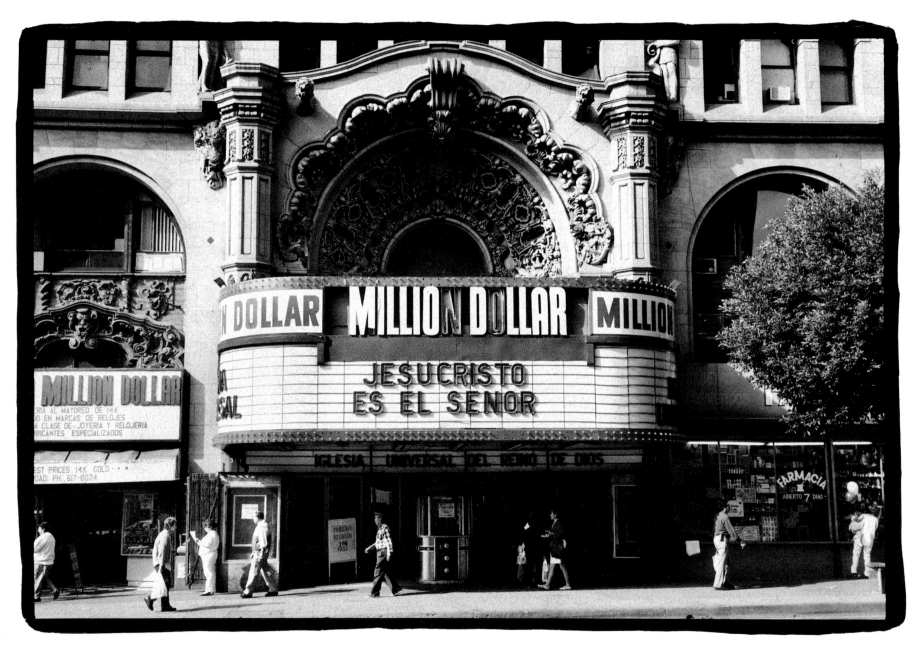

Raul Herrera
Million Dollar Theater, *downtown Los Angeles*

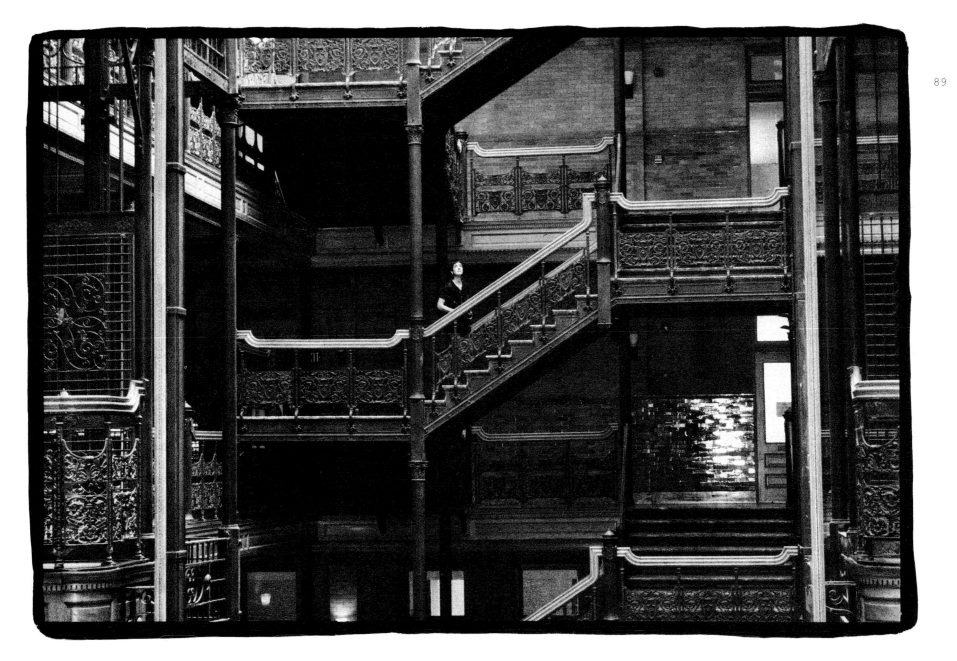

Sabrina Paschal
The Bradbury Building, *downtown Los Angeles*

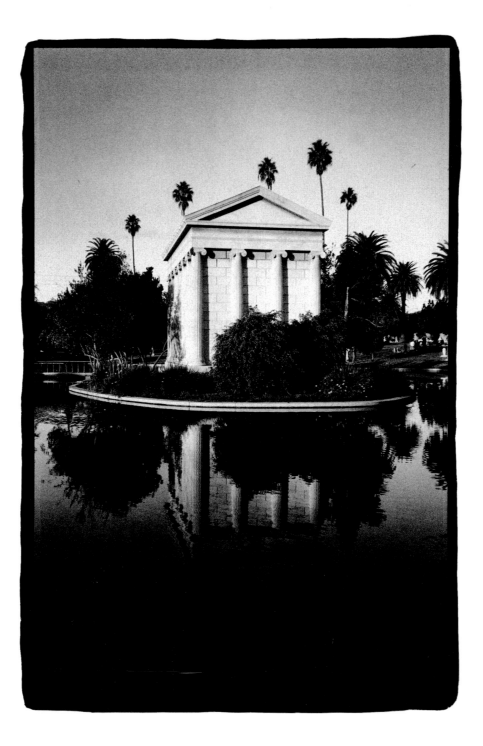

Raul Herrera
Hollywood Memorial Park, *Hollywood*

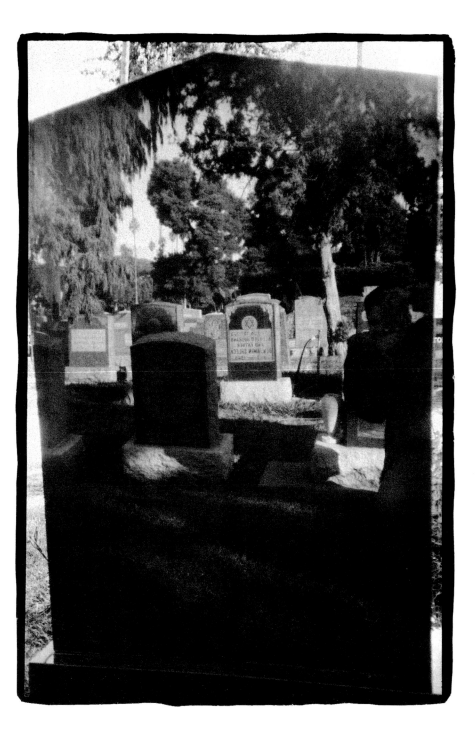

Raul Herrera Hollywood Memorial Park, *Hollywood*

Sabrina Paschal
Union Station, *downtown Los Angeles*

Abbey Fuchs
Union Station, *downtown Los Angeles*

We see a different side of Los Angeles...it's not always sunny with blue skies. I guess teenagers and us young people, we see the other side. Some from the south side, the north side, the east, and the west. But it's all the same, yet different. We get to see that other side of L.A. We can't ignore it because we live in it and we are a part of it. We grow up in it. RAUL

Raul Herrera
Downtown skyline from Griffith Park Observatory, *Los Feliz*

Afterword

Even before I learned it would be the signature photograph of the exhibition, I was haunted by the image of the young man walking into the underpass and away from the light. He is entering a shrinking as well as a darkening world, a world where stealth and concealment may be his only protection. The graffiti on the walls are a warning of danger, and the boy seems fearful and lonely. So I thought.

Then I read the notation on the back of the photograph—"tagger"—and was startled into a new understanding. The boy is no less fearful or lonely for being himself an author of threatening scrawls on the walls. What I hadn't realized was the complexity of the message. The neighborhood remains dangerous, but the graffiti have been transformed into something more than intimidation. It is also a cry of alienation, and—behind the bravado—a plea for comfort.

"Picture L.A.: Landmarks of a New Generation" is tagging on the order of art, revealing the city through the clarity of young eyes, so that even we adults have no choice but to see it as it is.

"I think adults try to filter out homelessness and those who are down on their luck," says Abbey. And Raul says, "The homeless are…in every part of town, in every corner, in every freeway, every-where." Indeed, the homeless have land-mark standing for several of these artists, and their concern has resulted in impor-tant perceptions. Homeless people mak-ing their own order amid symbols of chaos is a powerful vision of truth.

That gangsters flashing signs con-stitute a landmark stretches that term as the exhibition intends. It also suggests awareness that the world is circumscribed by conditions beyond one's control. The scenes in the barber shop are tranquil, but the view through the windows sug-gests that this landmark is a refuge from mean streets.

There is a lot more here. Images of commercialism reflected in glass doors or glimpsed on a billboard across Sunset Boulevard may be fleeting, but the value system they represent is one of L.A.'s definitive landmarks. And monumental freeway ramps seem as permanent as geo-graphical features—until they're reduced to rubble by geological forces and become landmarks of another kind.

This is "honest seeing," as Lauren Greenfield says in her eloquent account of how the photographs came about: compassionate but unsentimental. L.A. may be a young city, but these young pho-tographers would have us remember that destruction and decay are sufficiently

with us to be designated landmarks.

Now look at the picture of the photographers themselves: a shy smile, a look of bold self-confidence, energy, and bright-eyed intelligence. To be sure, they have discovered a secret adults hide even from themselves—that the idealized world we wish for our children is often different from their reality. But these faces contain the potential for other discoveries, too, as the photographs reveal.

The patio has been ravaged by fire, but the kid on the Power Trac is still having fun. So is the girl in the party dress, while adults on the sidewalk are lost in thoughts of their own. There is real power in that exuberant slam dunk, implacable style on the part of the Venice Beach rolling Rockettes, and knowing scepticism on the face of a fashionably dressed child shopper in Beverly Hills. Teenagers on Hollywood Boulevard transcend with sheer vitality the seediness of that traditional L.A. landmark.

Elsewhere, a clerk escapes by telephone from his work at the counter. A runner stretches his legs on the beach, and a couple shares the calm of the ocean at sunset. Buddhas in a Korean shrine recall the vast diversity of L.A., as well as the infinite richness of the city.

Adults will respond in different ways as they contemplate the observations of their successors. But there's no avoiding a sobering question: If this is the way L.A. looks to the young, what will our city be like in the future? The question is unanswerable, but this collection of photographs is reassuring.

First, we see in these pictures a devotion to telling the truth.

Second, the artists are changed by what they see. "I didn't pay attention to the landmarks," says Osofu. "Now I really care about things that may not be here two years from now."

Finally, landmarks for them are not the remnants of a dead past, but signposts for what is to come. Daniel puts it this way: "We need [landmarks] so we can learn more about our history… so we can know how the past was so we can make a better future so we won't make the same mistakes they did."

As one of "them," I am impressed and grateful for the insights of these acute and thoughtful observers, and I am moved by the beauty of their expressions.

Warren Olney
Host, *Which Way, L.A.?*
KCRW

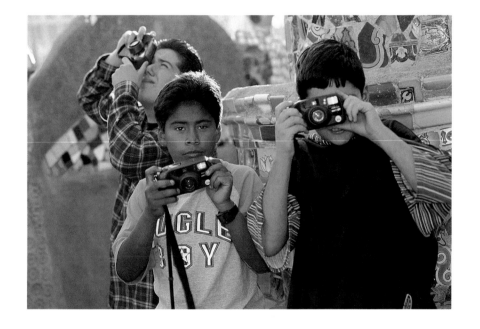

Lauren Greenfield
Raul Herrera, Luis Castro, and Daniel Hernandez at Watts Towers

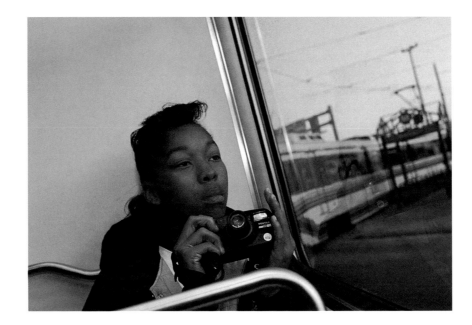

Lauren Greenfield
Sabrina Paschal on the Metro Blue Line

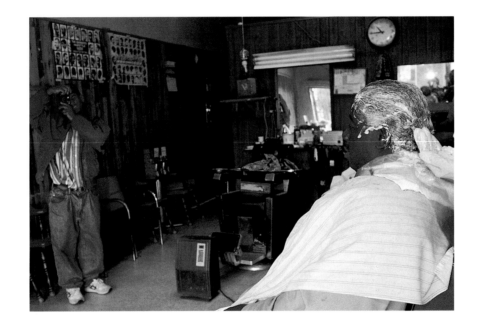

Lauren Greenfield
Osofu Washington at Clay's Barber Shop

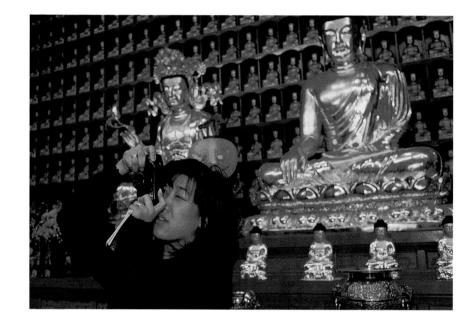

Lauren Greenfield
Younghee Seo at Los Angeles Dal-Ma-Sah Temple

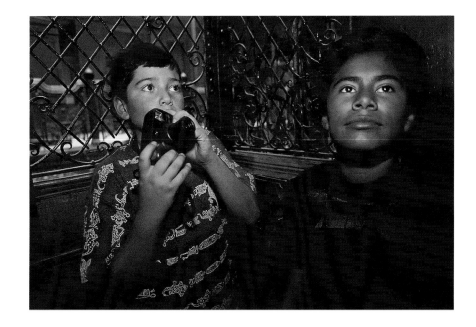

Lauren Greenfield Daniel Hernandez and Luis Castro at the Bradbury Building

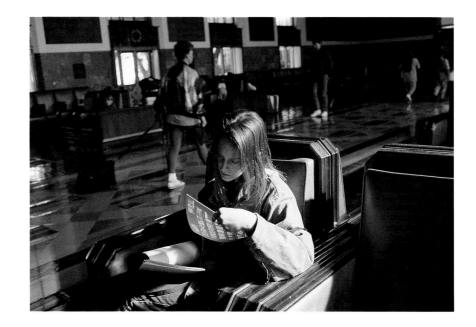

Lauren Greenfield
Abbey Fuchs at Union Station

Lauren Greenfield
Raul Herrera in downtown Los Angeles

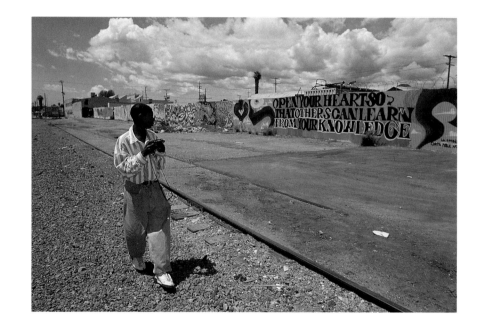

Lauren Greenfield
Ennis Beley in South Central Los Angeles

Biographies

ENNIS BELEY is from South Central Los Angeles. Thirteen years old at the time of the "Picture L.A." project, he is presently in the seventh grade at United World International School. In 1992 and 1993 he spent six months videotaping his life for a BBC documentary entitled "L.A. Stories." He would like to be a journalist when he grows up. Besides photography, his hobbies include talking on the phone, following current events, and reading *Low Rider* magazine.

LUIS CASTRO was born in San Salvador and currently lives in Koreatown. Twelve years old during the project, he attends seventh grade at Crossroads School in Santa Monica. He is not sure what he wants to be when he grows up. Since "Picture L.A.," he has been photographing his trips to different places. His hobbies include model building and sports.

ABBEY FUCHS has lived in Hollywood since she moved from New York at the age of three. Sixteen years old at the time of the project, she recently graduated from Fairfax High School where, among other things, she studied photography and played on the school volleyball team. She is currently attending Cal State Sonoma, majoring in communications. Prior to

"Picture L.A.," Abbey had no thought of being a professional photographer. Now she is contemplating the idea.

DANIEL HERNANDEZ is from Boyle Heights. He was ten years old when the project began, and is now in the sixth grade at Griffin Magnet Junior High School where he is studying one of his favorite subjects — computers. He also enjoys playing football and basketball. Daniel is in the third generation of his family to be born in Boyle Heights (his grandparents built the house they live in). He says he wants his neighborhood to stay the same because he likes the landmarks.

RAUL HERRERA is from the Hollywood area and was eighteen at the time of the project. He graduated from Hollywood High School where he first studied photography. Now attending Los Angeles City College, Raul is majoring in photography and journalism. He wants to be a photojournalist, "get out of L.A., and make something of myself." His family is originally from Mexico City.

Daniel Hernandez
Self-portrait

Sabrina Paschal
Self-portrait

SABRINA PASCHAL lives across the street from the Hacienda Projects in Watts. She was fourteen years old and in the ninth grade at Markham Junior High when the project began. Sabrina is studying video at the Watts Towers Arts Center, and her hobbies include basketball, rollerblading, and swimming. She would like to be a pediatrician.

YOUNGHEE SEO lives in Hollywood but spends most of her time in Koreatown. She arrived from Korea in 1991. Eighteen years old while participating in "Picture L.A.," she recently graduated from Fairfax High School after first attending Hollywood High School. Her parents still live in Korea, and she said that photographing old people in Koreatown reminded her of her parents' life. Younghee is studying design at Los Angeles Community College, and plans to attend art school.

OSOFU WASHINGTON lives in Inglewood. A student at Crenshaw High School, he was sixteen when the "Picture L.A." project began. He is an avid basketball player and shares a love of music with his family. He also enjoys computer graphics and hair styling. Osofu wants to be an entrepreneur and open his own restaurant or barber shop. He said that during the project he realized things about L.A. that he never before knew.

LAUREN GREENFIELD is an award-winning documentary photographer affiliated with the Sygma Agency. Since graduating from Harvard University in 1987, her work has been exhibited in New York, Boston, and Los Angeles, and has been published widely in national and international magazines including *Time, Life, Geo,* and the *Los Angeles Times Magazine.* Her major projects have included photographic essays on French aristocracy, Maya Indians in Chiapas, Mexico, and Los Angeles youth, the latter two underwritten by the National Geographic Society.

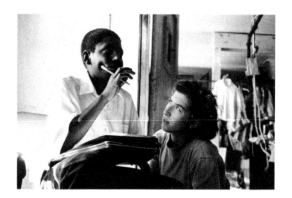

Jessica Karman
Ennis Beley and Lauren Greenfield

When Lauren Greenfield first asked me to be part of "Picture L.A.," I thought I was too busy and didn't have the time. She wanted me on this project, so I made the time. That's how Lauren is.

My role was to accompany some of the kids as they set out to document sites that they considered to be landmarks. I have lived in L.A. since I was two, but through the eyes of these young photographers I was introduced to a city I never really knew. Each day was a new adventure.

Like the day Ennis and I went downtown for the Williams/Watson trial verdict. The reporters gathered there seemed more interested in Ennis than in the case. They all knew him from the Rodney King beating trial when he was working on a video project for the BBC, but they acted as though he was another one of them—another one of them that they were very happy to see. It was an incredible sight, and I felt proud to be his friend.

With Raul I discovered a place known as the Belmont tunnel where we went on the average of once a week. This 1920s bank building housed six to eight homeless people at a time. Some were permanent, some were just passing through, but they were always happy to see us and to be photographed as a part of this project.

With Osofu I discovered Hollywood Park, a place he was taken to regularly as a child by his grandfather. Now retired, his grandfather goes there almost daily. Unfortunately, we never ran into him. I would have liked to meet him and, of course, to photograph him.

Then there was Sabrina, who literally spoke with her eyes. The whole time we were together, she barely said a word, but her photographs said it all. She took me all over Watts and through the Hacienda Projects near where she lives. She introduced me to her friends and family and her community. I especially loved her portrayal of her family.

I could fill this book with all the wonderful experiences we had. Ennis, Raul, Osofu, and Sabrina were the four young photographers I had the incredible opportunity to work with. If I could have, I would have worked with Abbey, Daniel, Younghee, and Luis, too. If I could, I would do it all over again.

Jessica Karman
Project Assistant

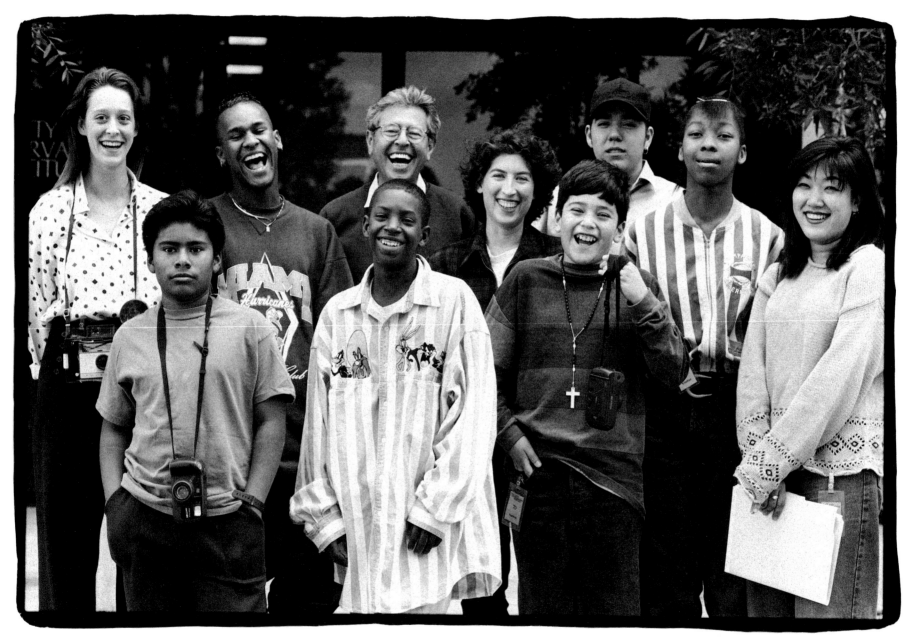

Jessica Karman *Back row:* Abbey Fuchs, Osofu Washington, Miguel Angel Corzo, Lauren Greenfield, Raul Herrera, Sabrina Paschal.
Front row: Luis Castro, Ennis Beley, Daniel Hernandez, Younghee Seo.

Luis Castro
The Getty Center under construction, *Brentwood*

Concept
Miguel Angel Corzo

Director
Mahasti Afshar

Director of Photography
Lauren Greenfield

Assistants
Jessica Karman
Juliann Tallino

Editor
Jeffrey Levin

Coordinator
Anita Keys

PHOTOGRAPHY

Ennis Beley

Luis Castro

Abbey Fuchs

Daniel Hernandez

Raul Herrera

Sabrina Paschal

Younghee Seo

Osofu Washington

EXHIBITION

Curatorial Assistance, Inc.
Graham Howe, Director

CATALOGUE

Designer
Vickie Sawyer Karten

Printer
Gardner Lithograph

Photo-editing Consultant
Leah Painter Roberts

Exhibition and Catalogue Photographs
Printed by X·IBIT

VIDEO

Producer/Director
Stuart Silver

PUBLIC INFORMATION

Philippa Calnan
Kathy Barreto
Dale Kutzera

Lauren Greenfield, The photographers at the Getty Center, *Brentwood*

Acknowledgments

The participants of "Picture L.A." wish to thank the following for their assistance and support:

Mercedes Abdullah

Brian Armstrong

William Armstrong

Miguel Arteta

Fenton Bailey

Randy Barbato

Jeff Boyer

Judy Campbell

Ron DeVeau

Frank Evers

Isaac and Rosa Flores

Brandon Francis

Dick Fuchs

Pan Fuchs

Willie Furnace

Howard Glen

Barry Gordon

Patricia Marks Greenfield

Teresa Grimes

Rubin and Helen Guillen

Sylvia Guillen

Diane Hall

Ted Hayes

Eddie and Anna Hernandez

Georgina Herrera

Daniel Hinerfeld

Dr. Jeanne Hon

Jim Hubbard

Michel Karman

Dorothy Kim

Eliane Laffont

Selina Lewis

Alva Libuser

Darryl Medeen

Margo Neal

J. P. Pappis

Allison Pollet

Blanca Quiroz

Sarah Shokrian

Maria Silver

Leslie Sokolow

Jan Sonnenmair

George Spitzer

Vira Stevenson

John Thompson

Philip Truelove

Father Carmine Vairo

Lamar VanSciver

Travis Walker

Rick Washington

Roseana Washington

Stills Williams

Brian Wolf

and

Adolph, Bebie, Gregory, Hassan, and Tracy

Beverly Wilshire Hotel

Boyle Heights Salesian Boys and Girls Club

Carden Malibu School

Catellus Development Corporation

Chateau Marmont hotel

Clay's Barber Shop

Crenshaw High School

Crossroads School

Fairfax High School

Genesis 1

Hollywood High School

L.A. Youth

Photo Impact

United World International School

Watts Towers Arts Center

The Yellin Company